Five Painters in New York

Whitney Museum of American Art, New York

Five Painters in New York

BRAD DAVIS

BILL JENSEN

ELIZABETH MURRAY

GARY STEPHAN

JOHN TORREANO

by Richard Armstrong and Richard Marshall

Copyright © 1984
Whitney Museum of American Art
946 Madison Avenue
New York, New York 10021

Library of Congress Cataloguing in Publication Data
Armstrong, Richard.
 Five painters in New York.

 "Exhibition: March 21-June 17, 1984—"T.p. verso.
 Includes bibliographies.
 1. Painting, American—New York (N.Y.)—
Exhibitions.
2. Painting, Modern—20th century—New York
(N.Y.)—Exhibitions. I. Marshall, Richard, date.
II. Whitney Museum of American Art. III. Title.
ND235.N45A75 1984 759.147'1'07401471
84-3579
ISBN 0-87427-018-9

Contents

FOREWORD

The major purpose of the exhibition program of the Whitney Museum of American Art is to recognize the accomplishments of living American artists. Through group shows such as the Biennial Exhibition, an intense, ongoing effort is made to assess quality and innovation in an artist's career. These exhibitions summarize recent American art and bring together work in a variety of media by artists throughout the country. Our collective understanding of the 1970s owes a great deal to those exhibitions and to such Permanent Collection surveys as "Minimalism to Expressionism," held in 1983.

When an artist has demonstrated consistent achievement, confirming a sustained talent, an attempt is made to present the artist's work in depth. "Five Painters in New York" very consciously serves that purpose, offering a comprehensive consideration of the work, produced in the past ten years, by five artists representative of their generation. In addition to endorsing the work of these artists, this exhibition also chronicles, in part, developments in New York City during the past decade. "Five Painters in New York" does not propose any stylistic continuities between these artists. They in fact take markedly different approaches, but each has been at the forefront of painting during the last ten years. As a whole their work forms an important link between the Minimalist-Conceptualist emphasis of the late 1960s and the widespread figurative subjectivity of the current moment.

On behalf of Richard Armstrong and Richard Marshall, co-organizers of the exhibition, I express gratitude to Brad Davis, Bill Jensen, Elizabeth Murray, Gary Stephan, and John Torreano for their generosity of spirit. We are indebted to lenders for their willingness to share these paintings. Commercial representatives of the artists, including Mary Boone Gallery, Paula Cooper Gallery, Holly Solomon Gallery, Washburn Gallery, and the former Hamilton Gallery, all in New York, as well as Susanne Hilberry Gallery, Birmingham, Michigan, and Margo Leavin Gallery, Los Angeles, responded generously to all inquiries and requests, thereby greatly facilitating the organization of the exhibition.

TOM ARMSTRONG
Director

INTRODUCTION

"Five Painters in New York" presents the work of a small group of artists—Brad Davis, Bill Jensen, Elizabeth Murray, Gary Stephan, John Torreano—related by sensibility and circumstances, rather than by any obvious stylistic cohesion. This exhibition surveys the works they have produced during the past dozen years and reflects the development of their styles and concerns. Although each artist pursues a distinct approach to painting, using various styles, concepts, formats, and materials, they have significant biographical features in common: all were born between 1940 and 1945 and are members of the generation of artists who began their careers in the late 1960s and early 1970s. Each has maintained a continuous allegiance to painting as a vehicle of expression, even during a period when this endeavor was often discouraged and denigrated. In addition, each artist chose to move from another area of the United States to New York—specifically the art community of Lower Manhattan—to work and live.

Much of the art made during the 1970s initially emerged as a response to the prevailing aesthetics, in this case those of Pop, Minimalism, and Conceptualism. Minimalism in particular strove to rid art of personal reference, subjective expression, and allusion to representational imagery. However, with the next generation of artists this kind of reductivism began to lose its grip. Because artists started to investigate alternative and varying modes of expression, the art of the 1970s has most frequently been described as "pluralistic," implying a variety of styles, media, and ideas that seemed fractured and disjointed, with no single expressive mode dominating. But the diversity is deceptive, for much post-Minimalist art, including that of the five painters presented here, displays a similar goal: to reinvigorate art with personal content, meaning, and imagery.

Although not commonly recognized, the years 1973–74 were a watershed in contemporary art. It is becoming clear that at this time a number of young artists began working in what we can now see as their mature style, with the five painters here leading the ranks. These painters have consistently produced strong and challenging work. They are employing personal and intuitive forms and images, unconventional ranges of color with emphasis on surface texture, and they imaginatively explore that ambiguous area between abstraction and representation. Viewed in a single exhibition, their work confirms the ongoing importance, intelligence, and vitality of recent American art.

RICHARD MARSHALL
Associate Curator, Exhibitions

Brad Davis

Swastikas, fierce eagles, and a giant, wreathed dagger are among the militaristic symbols Brad Davis chose as the dominant imagery for his paintings of the early 1970s. They were curiously out of step with the anti–Vietnam War fervor of the time and remain difficult to decipher in terms of Davis' stated intentions. Intensely iconoclastic from the beginning of his career, Davis has always desired wide philosophical interpretations, rather than strictly formal ones, for his work. About such paintings as *Eagle* (1972) and *Guerrilla Warfare* (1971–73), he explains: "Power politics and this luminous phantasmagoria become a metaphor for the balancing of opposing forces, and the light and energy stand for the unity of consciousness that is the context of the play of opposites."[1] However the paintings are interpreted, their weird superimpositions of fascistic signs on a mottled ground executed in a lyrical abstract style are the startling harbingers of his extra-formal ambitions.

In technique, the paintings were an outgrowth of the abstract, looping, calligraphic work Davis had been making since the late 1960s, partly in reaction to the spare, geometric rigidities of Color Field painting. His paintings of the 1960s and those of the early 1970s exploited the pictorial possibilities of an unusual working method. With the canvas on the floor, he placed large sheets of polyethylene plastic over the wet acrylic paint. The paint pulled the plastic down in a suction action, so that a marbleized pattern of uneven opacity was formed as the acrylic dried. Davis would then remove the plastic sheet and begin highlighting and darkening certain areas of the all-over field by hand. This random ground can be likened to another kind of automatism—of manipulated materials instead of a calligraphy of the subconscious.

Only after Davis had confirmed the pattern made by the plastic and paint would he start to put down the centralized representational imagery. This he had extracted from various Nazi medals, in an effort not to aggrandize fascism, but to isolate its most potent visual symbols in a paradoxically lush, beautiful context. This way Davis meant to internalize the powers of the symbol, "to find the qualities of that kind of oppression in your own heart," and thus invest them as valuable tools of self-awareness.[2] Another observer perceived the swastika works as "parodying, with an acknowledged contemporary symbol of oppression, the Formalist canons and strategies that . . . had led to the inner oppression of the artist"[3]—a more worldly analysis than Davis' own, but an accurate one. In *Eagle*, gold leaf burnishes the wreath around the neck of the huge, looming eagle, its wings outspread in a menacing flourish. Davis saw connections between the bird and the artist's ego, an analogy of animals and people which played a significant role in many of his subsequent paintings.[4]

Guerrilla Warfare consciously evokes Jungian archetypes with its tangle of snakes writhing around an upright dagger that is pointed into a human skull. A murky red, blue, and green ground in this painting holds the more brightly colored snakes, an oak-leaf wreath, and the brilliant gold-leaf dagger.

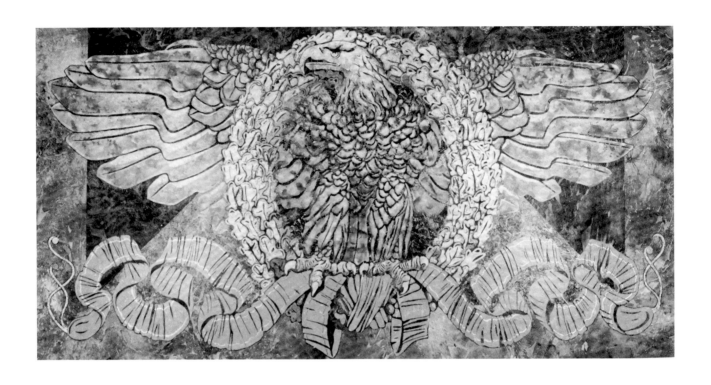

BRAD DAVIS

Eagle, 1972
Acrylic and oil pastel on canvas
91½ x 182 (232.4 x 462.3)
Collection of Holly and Horace Solomon

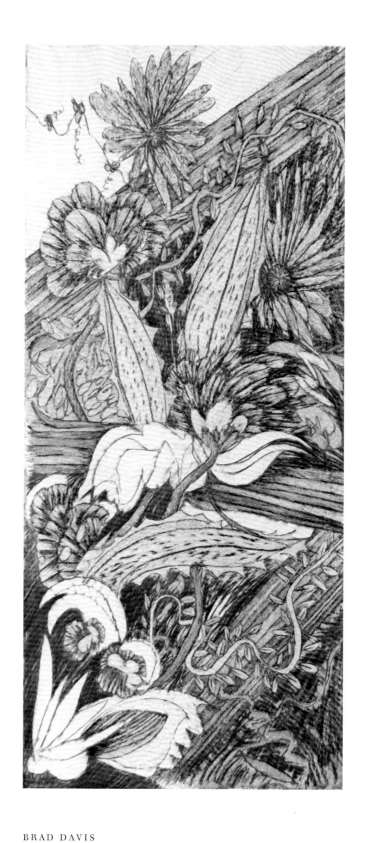

BRAD DAVIS

Blue Zig Zag, 1975
Acrylic, oil pastel, and graphite on canvas
96 x 44 (243.8 x 111.8)
Collection of Joseph Spellman

After two years of meticulous reworking of *Eagle* alone, and deep involvement in the series, the intensive labor and ponderous symbolism made Davis abandon both the technique and the imagery. He began a series of large drawings that gradually evolved from the all-over fields of the emblematic paintings into dense, floral landscapes. Around 1973, Davis had become involved with the teachings of the religious philosopher and Indian yogi Muktananda. He credits the yogi's influence with both his new pastoral subject matter and its less strident style.

In *Black Orchid* (1975), the exuberant, writhing forms characteristic of Davis' older work were transformed into idiosyncratic plant shapes. Vegetation of a most fanciful sort supplanted aggressive fauna and recognizable symbols. Quixotically asymmetrical and spatially complicated, these paintings were a breakthrough for Davis; they mark the beginning of the imaginary landscapes that became his ongoing subjects.

By 1975, Davis was associated with the group of younger painters and sculptors coming to be known as "pattern and decoration" artists. He shared with them an informed interest in Oriental and Near Eastern art and a desire to reintegrate fine art with life, a desire manifested in his work by his use of common polyester cloth as framing devices for his paintings.

As his landscapes developed and became more and more embellished, they earned a place among the most forceful representatives of the decorative movement. First asserted through the application of gold leaf to parts of the landscape fields (a move he now sees as a "step backwards to abstraction"[5]), Davis' decorativeness became more clearly apparent in the polyester borders with which he surrounded the central imagery.

The paintings assumed a more literal character as Davis sought to establish a particular time and event in each one. He began using real plant forms as models in 1976, basing his drawings on illustrations from a medieval herbal. The same year, with the sculptor Ned Smyth, he started research at the C.G. Jung Foundation library in preparation for a large, room-size collaborative installation, called *The Garden* (1977). The two artists settled on Early Christian and Indian religious symbols for the work, having been "drawn particularly to the images of water—cleansing, creative, soothing—and the palm—fecund and celebratory—that these traditions shared."[6] The ensemble mixed Smyth's cast concrete fountain and palm trees with large painted landscapes by Davis—conceived as variations of specific Chinese and Japanese painting motifs. A dependence on silhouette produced a greater legibility, making these paintings easier to read than the florid, fin-de-siècle landscapes that had occupied Davis in the previous few years. He sensed that "the ideas were embedded in the style, not on top of it, so you could catch them through the mood and feeling not through some more mental connection."[7] Spontaneity was becoming of paramount importance.

The five paintings that comprise the *Ming Snapshots* (1980) show Davis in a free, more blatantly decorative mode. All the paintings have a pink-blue, double-banded polyester border—what Davis refers to as the "somewhat brutish protectors of the charmed inner space."[8] Each painting is a rapidly painted "snapshot" of some exotic countryside idyll: oversize butterflies visit luscious poppy red blossoms in one; a water bird balances precariously on a reed in another; and an array of pastel colored plants enliven the rest. These are delicate, charming paintings that are as anomalous in their art historical context as the militaristic paintings had been. Perhaps the most funda-

mental commonality between the two sets of work was Davis' continued, though greatly expanded, use of high pitched color. The horrific, hallucinatory glare of the earlier pieces has been transformed into another dream-like state, one altogether more pleasant, even ecstatic. But for all his interest in landscape, Davis' palette does not replicate nature's. His color remains artificial and psychological, rather than physiological.

The large tondi that also occupied Davis during 1980—including *In the Daffodils*, *Top of the Peak*, and *Summer Wind*—show how adept he had become at particularizing each painting, by means of light, implied season, and narrative incident. *Summer Wind*'s abstractly patterned blue-brown border frames a dense composition that at first glance continues the border's tonal scheme: a blue and brown hydrangea-like plant weights the painting toward the left. To the right, orange-colored blossoms spring from delicate limbs, and in a tangle of blue-limbed underbrush a small bird sings. A lightly painted yellow ground creates the painting's atmosphere. It is a good example of Davis' skill in dissolving form into an animated, highly gestural scene that resembles the constant agitation of any closely studied scene in nature.

Top of the Peak seems to be keyed by color to the cerise and pink border that encircles it—but here Davis deliberately underscores the ambiguous orientation of the tondo: the magnificent pink flowers and the outcropping from which they seem to grow are positioned aslant. Writing of this period of Davis' work, Neil Printz noted: "He transposed the conventions of Persian and medieval painting—shallow, tilted spatial grounds, disjunctions of scale, saturated color, and decorated borders—to the scale of easel painting."[9]

Beginning in the late 1970s, dogs as human surrogates figure prominently in a number of Davis' larger paintings, most noticeably in the triptych *Dürer's Dogs* (1981). For Davis the dog could symbolize many roles: "the rascal, the lazy bum, the noble beast, the longing soul, the sentinel, the sage, and the movie star. He was Shiva's companion, a scavenger among the stars, a mythic beast, as well as the cartoon of human frailty and pretension."[10]

Dürer's Dogs, so named because the animals are quoted from those in Dürer's engraving of *St. Eustace*, represents a reprise and reinterpretation of some of Davis' early techniques and motifs. The print in the two polyester side panels, for instance, recalls his first floral paintings. The rushing stream in the background reiterates the importance of water, which appears as a symbol of oasis and healthful activity in many of Davis' paintings. The three implausibly colored canines here keep watch, however comically, over the place. In their cockeyed zaniness, they are a long way from the eagles of ten years earlier. The light, candy-colored palette and the quick, masterfully rendered strokes of the painting testify to Davis' ease with his maturing style.

More recently, Davis has returned to landscapes almost devoid of animal life. *Evening Shore* (1985) portrays water falling into a pool surrounded by curious, almost anthropomorphic rock formations. Bold strokes of dark paint, blues and purples, define the water and rocks, while various small strokes, some like stipple, activate the picture's surface. A red and black border frames the scene and reinforces its dusk-like tonalities. With *Jamaican Inlet* (1985) and a suite of related paintings, Davis relinquished the applied decorative borders: he felt that "the center has been more secured, my relationship to the inner and outer world has become more clear."[11] *Evening Shore* succeeds in establishing a single imaginary scene, while *Jamaican Inlet* can be

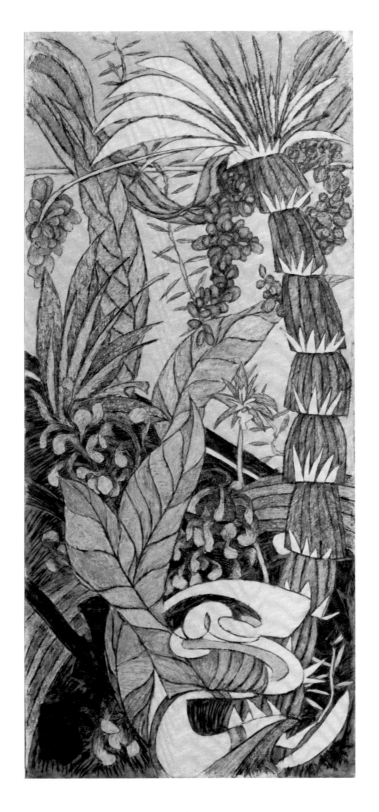

BRAD DAVIS

Black Orchid, 1975
Acrylic and oil pastel on canvas
96 x 44 (243.8 x 111.8)
Collection of Mr. and Mrs. Morton Hornick

seen as a compendium of Davis' preferred landscape elements—rocks, small trees, and exotic flora joined in an extended landscape (the painting is 15 feet long) by a surge of moving water. Rushing, then still at spots, the water produces a visual tempo for the reading of the painting.

More insistently than any other painter of his generation, Davis has looked outside the mainstreams of Western art for his inspiration. He has tempered the rage of his early paintings into a body of work that is unusual for its deliberate exposition of sensitive personal insight. His attempt to harmonize ancient Oriental conventions of picture-making with a contemporary vision continues to mark him as a loner; the unique and serenely beautiful paintings he had made since 1975 more than justify his iconoclasm.

1. Brad Davis, letter to Richard Armstrong, December 11, 1983; Artists' Files, Whitney Museum of American Art, New York.

2. Brad Davis, interview with Linda Cathcart distributed by the 98 Greene Street Loft, New York, April 26, 1972; Artists' Files, Whitney Museum of American Art, New York.

3. Bruce Wolmer, in "Reviews," *Art News*, 71 (Summer 1972), p. 15.

4. Davis, letter, December 11, 1983.

5. Brad Davis, interview with Richard Armstrong and Richard Marshall, November 5, 1983.

6. Brad Davis and Ned Smyth, "Collaboration catalogue statement," December 1, 1983; printed handout produced after the exhibition by the Holly Solomon Gallery, New York; Artists' Files, Whitney Museum of American Art, New York.

7. Davis, letter, December 11, 1983.

8. Ibid.

9. Neil Printz, in *Back to the U.S.A.*, exhibition catalogue, ed. Klaus Honnef (Bonn: Rheinisches Landesmuseum, 1983), p. 66.

10. Davis, letter, December 11, 1983.

11. Ibid.

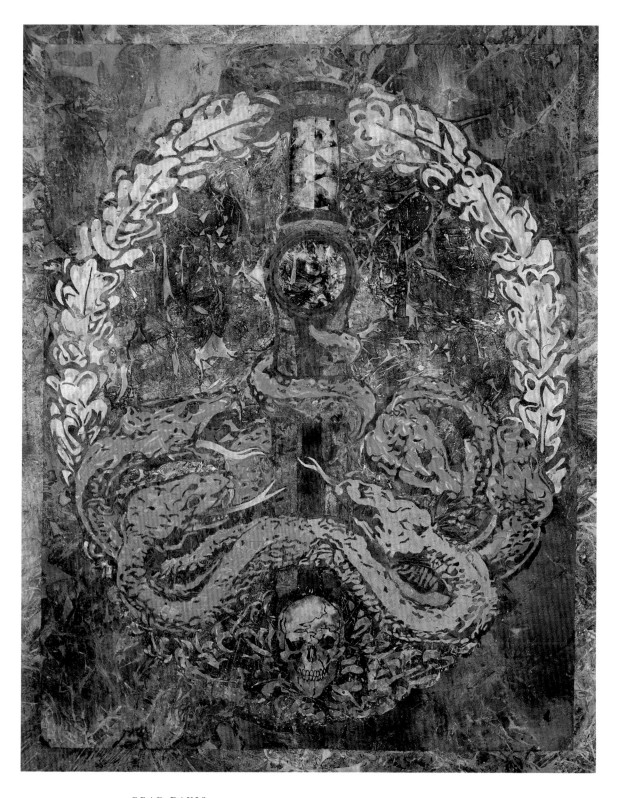

BRAD DAVIS

Guerrilla Warfare, 1971–73
Acrylic and metal leaf on canvas
100¾ x 81 (255.9 x 205.7)
Whitney Museum of American Art, New York; Gift of
Mr. and Mrs. William A. Marsteller (and purchase) 73.72

BRAD DAVIS

Ming Snapshots #1–#5, 1980
Acrylic and polyester fabric on canvas
Five panels, each 42 x 42 (106.7 x 106.7)
Collection of the Right Honourable the Earl of Ronaldshay

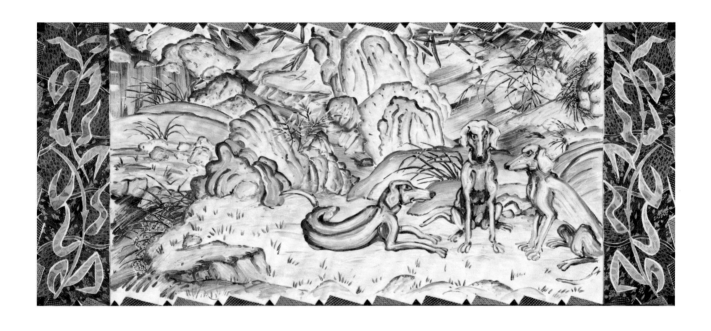

BRAD DAVIS

Dürer's Dogs, 1981
Acrylic and polyester fabric on canvas
Three panels, 60½ x 140 (153.7 x 355.6) overall
The Gelco Collection, Gelco Corporation, Eden Prairie, Minnesota

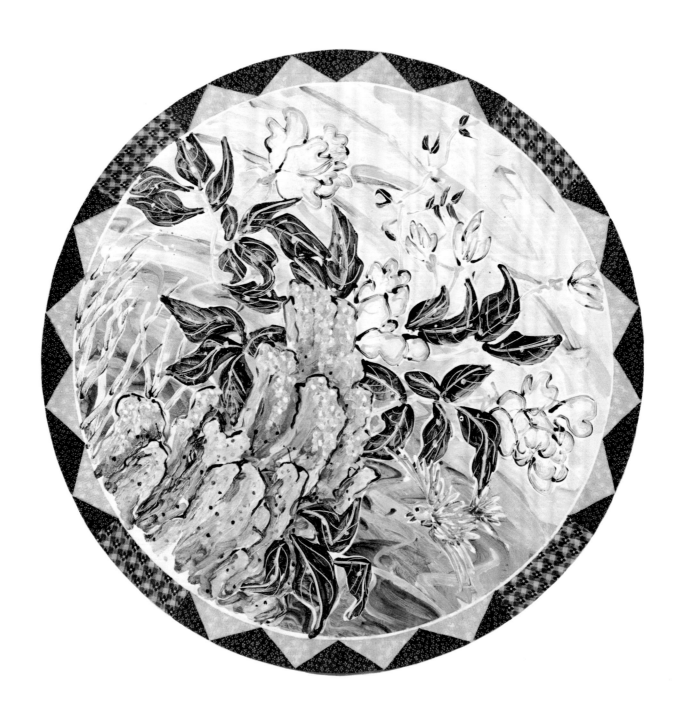

BRAD DAVIS

Top of the Peak, 1980
Acrylic and polyester fabric on canvas
48 (121.9) diameter
Collection of the artist, courtesy Holly Solomon Gallery, New York

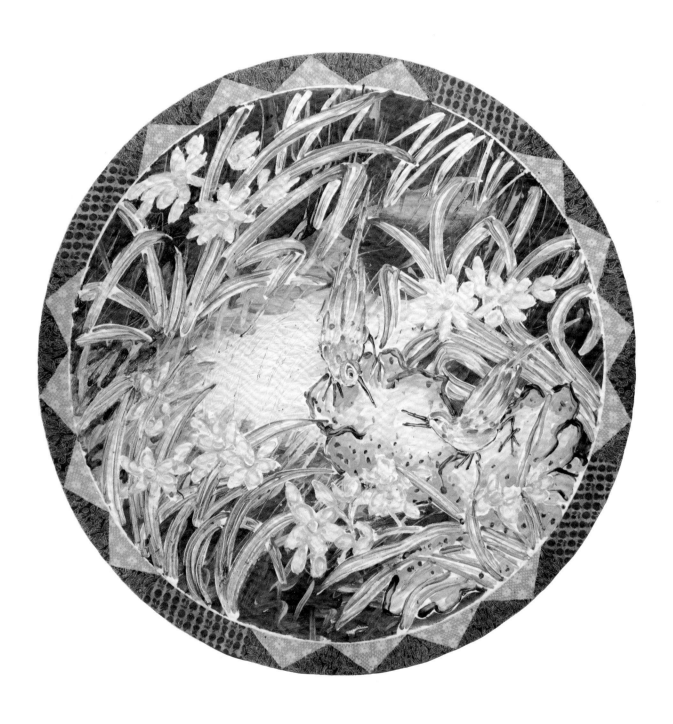

BRAD DAVIS

In the Daffodils, 1980
Acrylic and polyester fabric on canvas
48 (121.9) diameter
Private collection

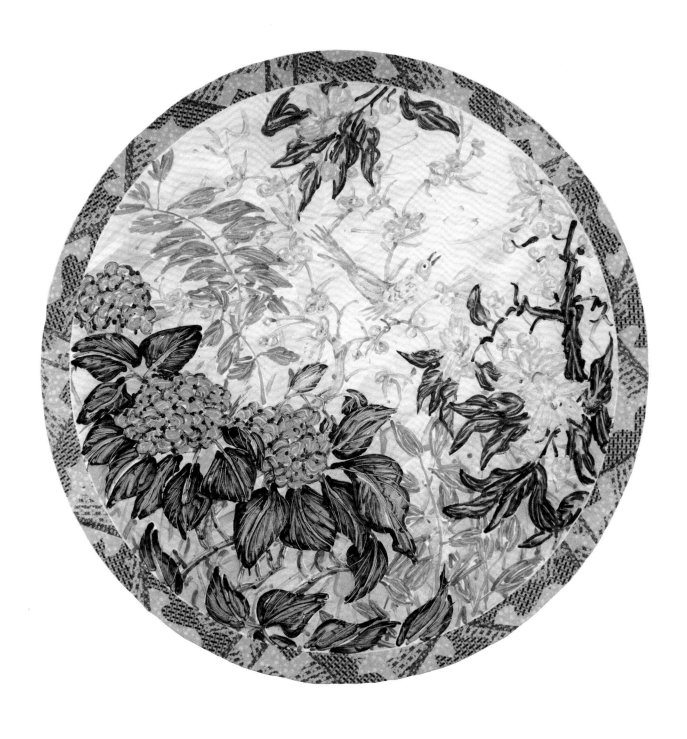

BRAD DAVIS

Summer Wind, 1980
Acrylic and polyester fabric on canvas
72 (182.9) diameter
Private collection

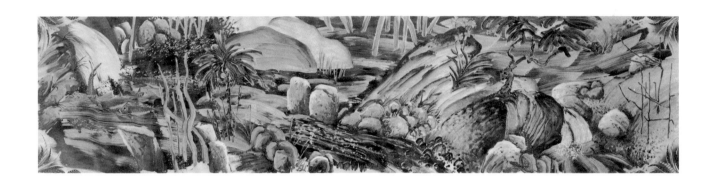

BRAD DAVIS

Jamaican Inlet, 1983
Acrylic and polyester fabric on canvas
42 x 180 (106.7 x 457.2)
Collection of Martin Sklar

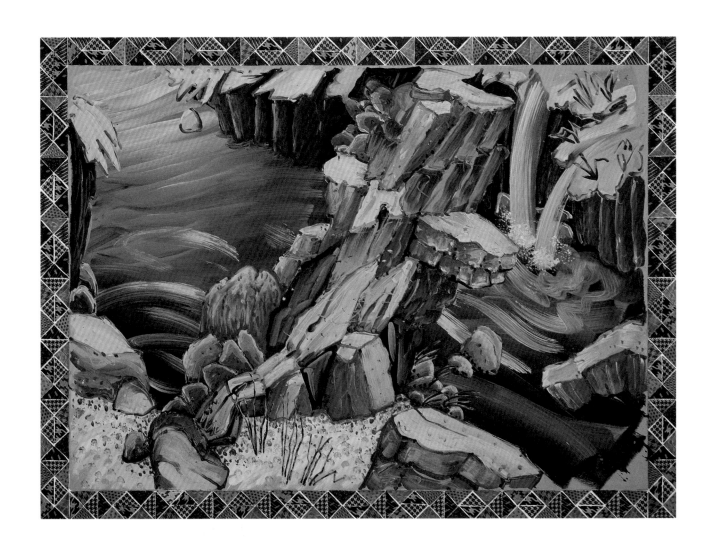

BRAD DAVIS

Evening Shore, 1983
Acrylic and polyester fabric on canvas
72 x 98 (182.9 x 248.9)
Private collection

Bill Jensen

When Bill Jensen left Minneapolis for New York in the summer of 1970, he brought ten drawings of spirals with him and he remembers that on the drive east all he could think of was "how to make them into paintings."[1] The paintings he made from them took up his first two years in New York. With their bulging, gestural coils, these works foretold the psychologically charged images that have animated Jensen's art ever since.

He made these early paintings with a combination of cement, hand-ground pigments, and binding varnishes. He seems to have been building a picture in a literal, rough-hewn variation of the Abstract Expressionist style he had learned at the University of Minnesota from Peter Busa, a New York artist and contemporary of Pollock's who had moved to the Midwest some years earlier. Jensen had become acquainted with other first- and second-generation New York School veterans—Edward Dugmore, Herman Cherry, and Mike Goldberg, among them—when they were visiting artists on the Minnesota faculty. These associations had strengthened his own bias for an expressionistic and gesturally structured picture.

By the time of his first solo show in New York, Jensen had produced an impressive body of these spiral drawing-derived paintings, all heavily impastoed with gritty, homemade paint. *Last* (1973), the final one in this series, shows his development toward an *art brut* style—one distinguishable as American by its larger-than-easel proportions, and by its primitive muscularity.

Four ovalish spirals coexist on the picture plane, each occupying a quadrant of the overall rectangle. An explosive red chevron, its apex shooting off to the right, visually connects the four areas while tonally jarring their predominantly green, pink, purple, and brown coloration. The painting's surface—a topography of thick, acrobatic marks and encrusted scars—forms an all-over, abstract bas-relief. In their modeling of paint in a literal, almost sculptural way, the paintings recall Ronald Bladen's heavily impastoed, bas-relief field paintings from the early 1960s or Al Held's impastoed gestural paintings of the same period. Jensen's paintings embodied attributes Irving Sandler had earlier called "concrete expressionism" to refer collectively to artists in a group show he organized at New York University in 1965.[2]

The massive, physical nature of these paintings made Jensen rely more and more on synthetic varnishes to bind materials to the canvas. By 1973 he had developed a serious, debilitating allergy to both the hand-ground pigments and the polyurethane varnish he used. Advised by doctors to stop painting with these materials, he reverted for a few months exclusively to drawing.

This enforced interruption in his working method had a profound effect on Jensen's subsequent art. He shortly began drawing with charcoal on sized canvases approximating drawing sheet scale. *Dark Silver* (1974) was among the first of these small, intimately scaled, drawn paintings. Interconnecting linear ovoids arch across the creamy, muddied ground of the work, configuring in shapes that allude to some uni-

BILL JENSEN

Dark Silver, 1974
Oil on linen on wood
22 x 28 (55.9 x 71.1)
Collection of Edith Gould

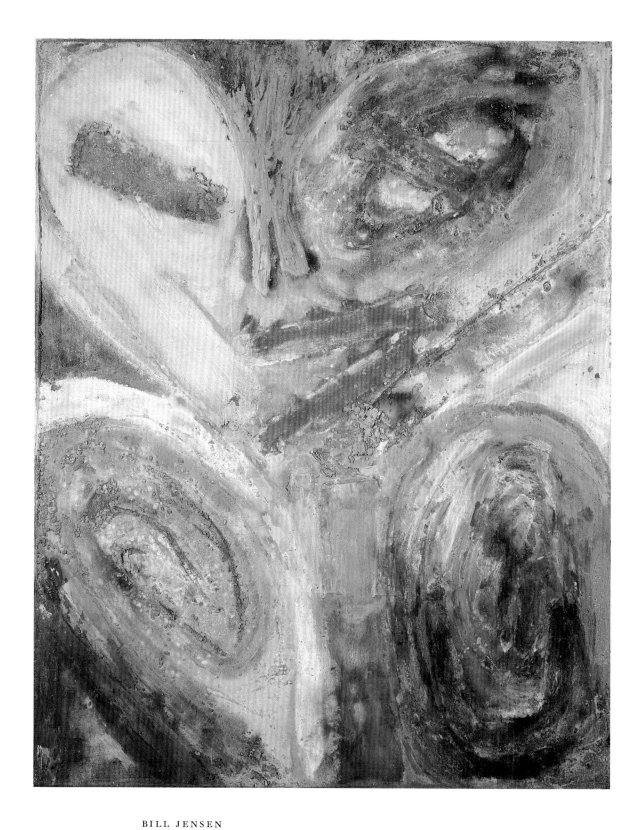

BILL JENSEN

Last, 1973
Oil and pigment on canvas
96½ x 77 (245.1 x 195.6)
Collection of the artist, courtesy Washburn Gallery, New York

versal, organic form. Charcoal lines sparingly engage the entire picture surface, compressing and simplifying the spiraling tension of *Last*.

The related, tiny *Black and White Painting* (1974–75) complicates and enriches the implied volumes of *Dark Silver*. Shaded into imploded and revolving clusters of tubular forms, the piece emanates the totemic sensations that Jensen came to exploit more fully in work that followed. Its miniaturized scale (the painting measures 11 x 9 inches) shows Jensen's imagery at its most extreme degree of compaction.

When he returned to oil paint as a medium in 1975, Jensen deliberately retained a small scale for his work, most commonly a 16 x 20 inch proportion. *The Purple Painting* of that year has a thin, translucent skin of color over a white ground, arranged to allow an eccentrically geometric underpainted white shape to come through and serve as the central figure. Jensen recalls seeking an "aerodynamically sound" painting. I think Jensen—mechanically gifted and a skilled craftsman—meant that he wanted a good fit, a successful reintegration of his gesturalness with his new scale.

The thicker, troweled-on paint of *The Red Painting* (1975–76) demonstrates a further elaboration of his former technique reduced to a much smaller scale. The painting's biomorphic connotations—an embryonic white spiral protecting and/or nurturing two leaf-like overlapping ovals—recall the cellular skeleton of the drawing in *Dark Silver*, as do the spectral, incised arcs covered by the red ground.

In *Freak* (1975–76), a conch-like white form bristles with radiating spokes. A small ellipse of smudged natural ground shows through the center of the form, as if the image had exploded from its own energy. Such centrifugal projections are rarely absent in Jensen's later work, as in *Mussels* (1977–78) or *Crown of Thorns* (1979). Most often radiating from the dominant symbol of the painting, they are sometimes only implied—by means of lines scored into the paint—as in *Resurrection* (1978). More than any other single element in Jensen's paintings, these emanations provoke enigmatic, almost mystical, readings. Jensen does not resist this mystification. In describing the process of inventing images, he speaks repeatedly of the expressive powers each painting assumes as he works on it.

Some of the scores of small notational drawings of nature he makes, mostly in ink or pencil and thickly cross-hatched and shaded, generate paintings or parts of paintings. But each painting is finally a distinct, cumulative work in itself rather than an enlarged translation of a drawing. Jensen's wet-on-wet method involves an intense collaboration between artist and material, so that the final imagery emerges as a revelation. Often he also makes scale drawings as he works on a painting, examining its structure as it builds. He sees these drawings as "levers—when I get stuck they will open up the painting." The impalpable essences that inspire the paintings are thus subjected to in-process analyses. Jensen's paintings are anything but accidental.

Jensen says that what he paints are the "feelings between people," a declaration that allies his work to the basic impulse of all symbolist art—to overcome somehow the separation between the real and the spiritual. He is aware of the great tradition of French Symbolist painting, as a title like *Redon* readily acknowledges. But Jensen's work is more atavistic, and his deliberately abstract paintings do not invoke specific symbols. A believer in the Baudelairean idea of *correspondence*—that visual, auditory, and olfactory sensations produce evocative correlations—Jensen chooses to find significant life-sustaining meaning everywhere and in all kinds of things. This receptivity to a variety of stimuli allows for the many moods of the artist's psyche: bright and dark

can be equally fecund. Both sides of Jensen find expression in his paintings.

Redon (1977) and *Seed of the Madonna* (1979) seem to have come from the joyous part. In the former, he distills the French artist's floral motifs into a single coil, darkly protective of the seed at its center. As it unwinds, the coil becomes first a rich burgundy then an accelerating, lightly scored azure. This activated figure sits atop a brilliant and moody yellow ground, also scored so that marks concentric with the circular seed-nutrient form are interrupted at each of the four corners by sprays of lines that embody light. This is Jensen at his most richly colored and luminous.

Two similar uncoilings transpire in *Seed of the Madonna*. An opaque white oval or mandorla lies diagonally across a neutral linen ground. A brown, paint-slathered neck glides up from the bottom edge of the picture. It curls off at the lower left like a tendril, ending in a small whitish circle (actually a black circle from which the paint has been scraped away)—a demonic force? The "neck" supports a throbbing circle of orangish yellow, mediated by a green-silver "leaf," its veins scored downward. A brooding blue-black shadow swells beneath the whole right side of the oval. This arc—an ominous presence temporarily eclipsed by the white—makes an elongated, mannerist movement counterbalancing the assertiveness of the brown neck and tendril. Here Jensen's imagery is as intimate as it is universal; he may in fact have had this painting in mind when he said, "I'm either painting the yolk of an egg or the whole world."[3]

A darker emotional tenor runs through other Jensen paintings. One observer has suggested that this more ominous work locates Jensen in a "discontinuous [American] tradition," that of "darkness. In it one finds the work of Albert Pinkham Ryder and the opacities of Ad Reinhardt and Jasper Johns."[4] With Jensen the more overtly disturbing works tend to have more concretely descriptive titles, such as *Mute* (1979). In this painting Jensen has drawn into the black overpainting, releasing white marks that in their unusual spareness and cross-hatching underscore what seems to be the tragic discord of the subjects: an unwillingness to communicate in one direction, an inability to do so in the other. Two amoebic forms are posited on the horizontal axis, two ovoid ones on the vertical. The white ovoids, weighty balloons or giant teardrops, verge toward each other but do not meet. Of the two lateral forms, the left one is seen face on, shrouded, while its counterpart is turned in profile in a position redolent with grief.

With such paintings as *Crown of Thorns* (1979) and *The Family* (1980–81), Jensen reaches his richest harmonization of color, gesture, and image. In the former, a black ellipse directly descended from the implied volumes of *Dark Silver* floats aslant on the background. On top of it throbs a white, more modeled, ellipse that contains a blue circle with radiating spokes. Sprays of white and yellow light shoot out in all directions. In *The Family*, one of Jensen's most enigmatic paintings, a golden ellipse stretches horizontally across the canvas, acting as a tabletop for a pair of supporting legs. Behind, the snow-covered peaks of a mountain range reflect light. Jensen's use of glazes and pentimenti adds luster to the densely arranged strokes of color characteristic of this mature work. Temperaments are imparted to otherwise inanimate forms and fields by means of subtle tonal shifts; there is a kind of modeling, one less concerned with traditional notions of plasticity in favor of one that elicits distinct resonances from everything in the paintings. Jensen himself claims to hear sounds from each work.

It is possible to see Jensen's paintings as a kind of pictorial counterpart to the small-scale sculpture Joel Shapiro had begun making in the early 1970s. Each artist's work can be thought of as a reaction to the physical and rhetorical excesses of a pre-

ceding generation—Shapiro's to the modular expansiveness and para-architectural size of Minimalist sculpture, Jensen's to what he perceived as the vacuity of the dominant painting style of the late 1960s and early seventies. In his decision to work with imagery abstracted, however distantly, from nature, and on an easel-painting scale, Jensen manifests his deep desire to connect his work with that of such early American modernists as Arthur Dove. Jensen has consistently separated himself from the intervening fifty years or so of American abstraction. In method and scale, he has become an old-fashioned painter by choice. The power of his imagery is timeless.

1. All quotations are from conversations with the artist, September-November 1983.
2. Irving Sandler, *Concrete Expressionism*, exhibition catalogue (New York: New York University Art Collection, 1965). Besides Bladen and Held, the show included works by Knox Martin, George Sugarman, and David Weinrib.
3. Quoted in Kathy Halbreich, *Affinities*, exhibition catalogue (Cambridge, Massachusetts: Hayden Gallery, Massachusetts Institute of Technology, 1983), unpaginated.
4. David Shapiro, in *Seven Artists*, exhibition catalogue (Purchase, New York: Neuberger Museum, State University of New York, College at Purchase, 1980), p. 21.

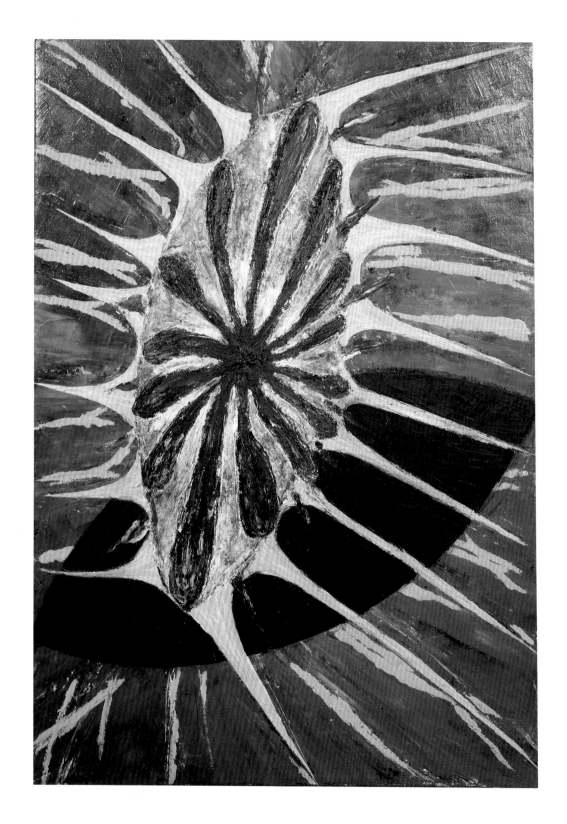

BILL JENSEN

Crown of Thorns, 1979
Oil on linen
16 x 11 (40.6 x 27.9)
Collection of Jerry Leiber

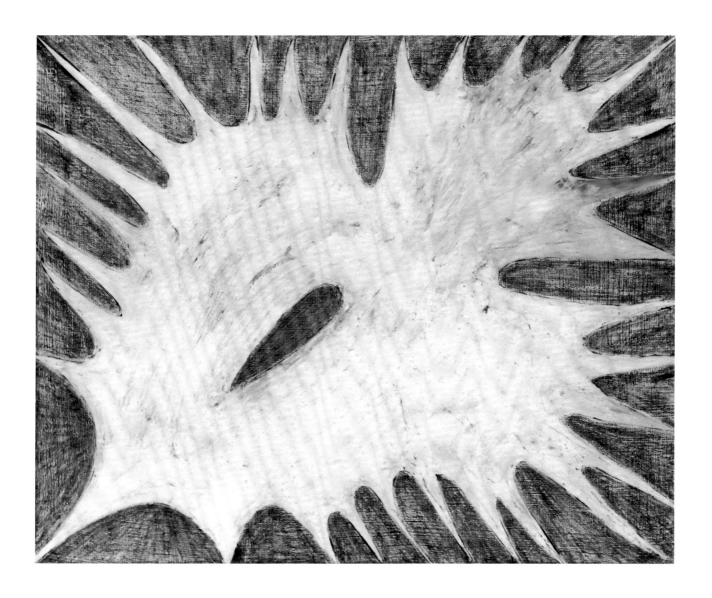

BILL JENSEN

Freak, 1975–76
Oil on linen
16 x 20 (40.6 x 50.8)
Collection of the artist, courtesy Washburn Gallery, New York

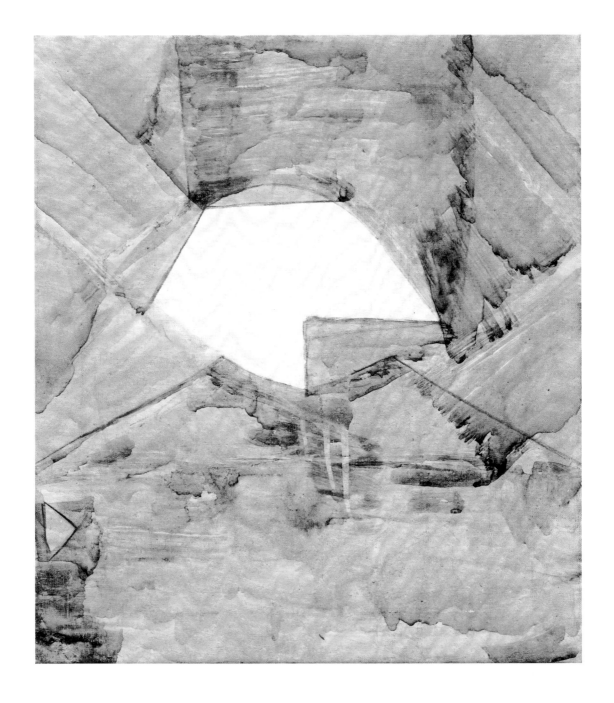

BILL JENSEN

The Purple Painting, 1975
Oil on linen
18 x 16 (45.7 x 40.6)
Collection of Connie Reyes and Ronald Bladen

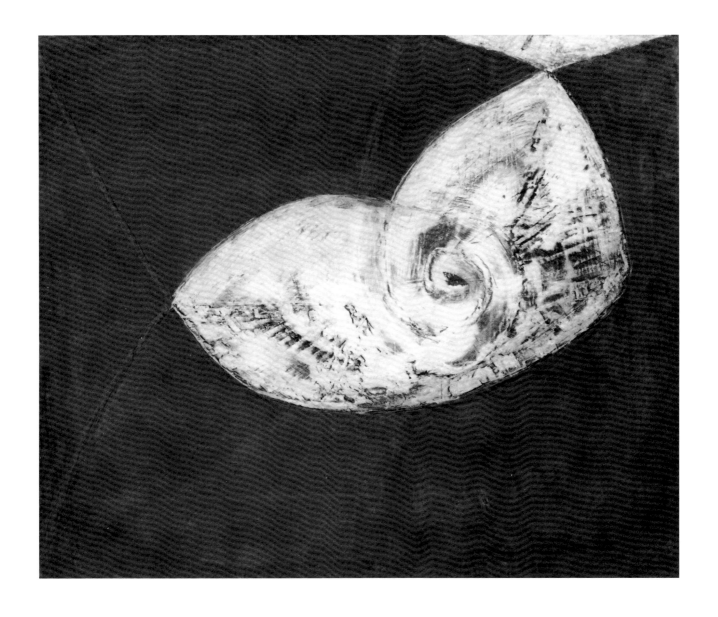

BILL JENSEN

The Red Painting, 1975–76
Oil on linen
18 x 22 (45.7 x 55.9)
Collection of the artist, courtesy Washburn Gallery, New York

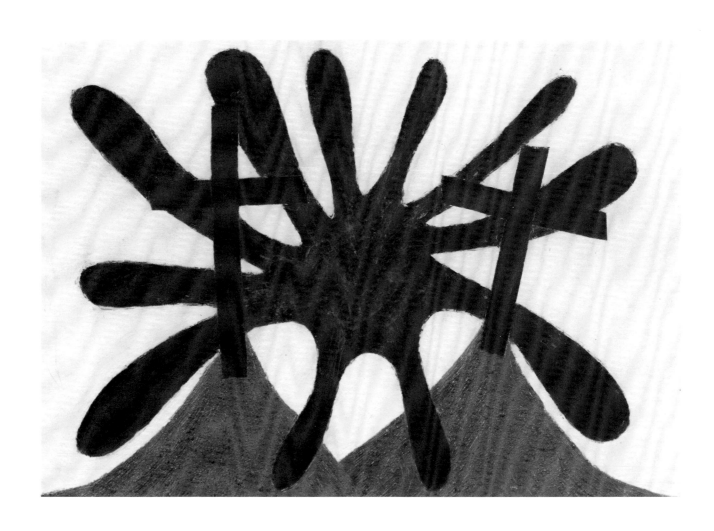

BILL JENSEN

Innocence, 1976
Oil on linen
12½ x 18 (31.8 x 45.7)
Collection of Mrs. William D. Carlebach

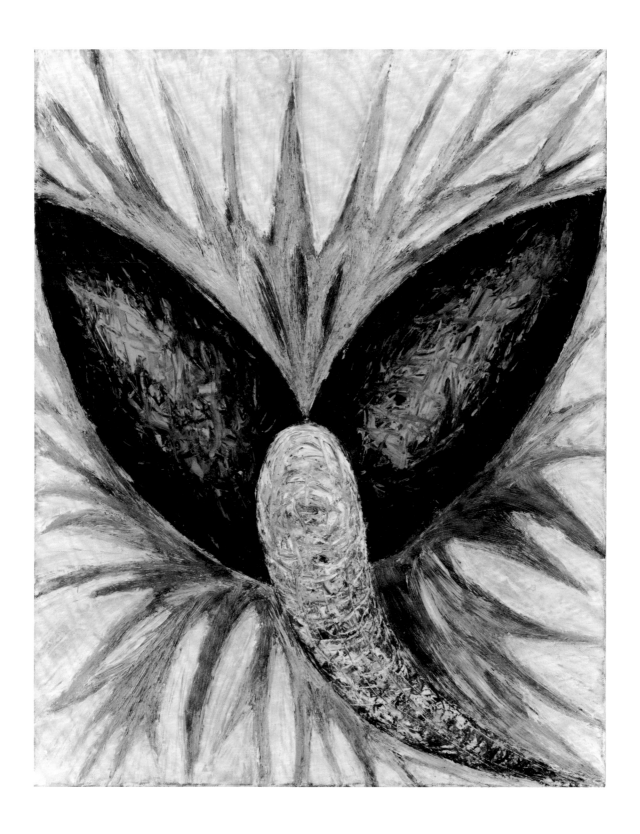

BILL JENSEN

Mussels, 1977–78
Oil on linen
20 x 16 (50.8 x 40.6)
Collection of Sue and David Workman

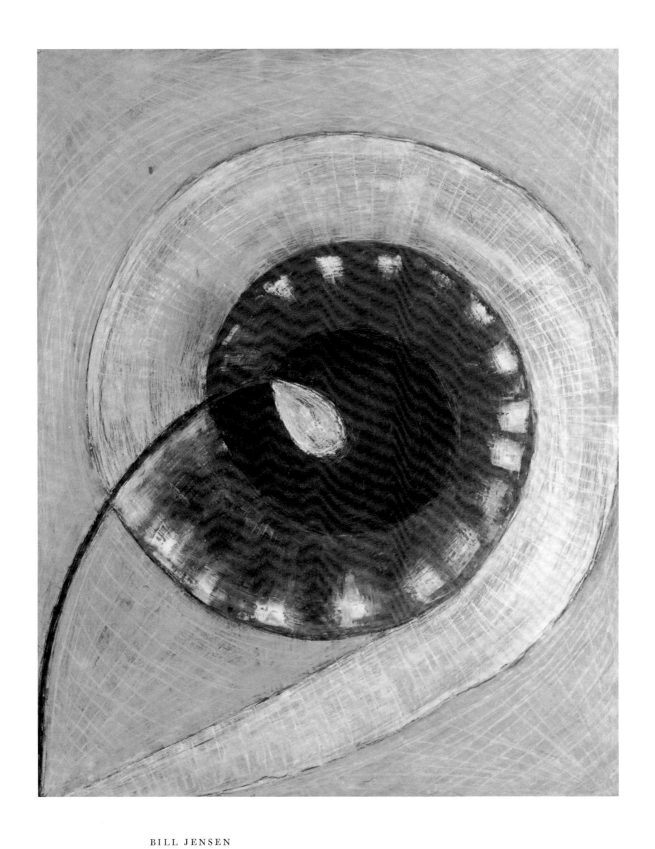

BILL JENSEN

Redon, 1977
Oil on linen
20 x 16 (50.8 x 40.6)
Collection of Edward R. Downe, Jr.

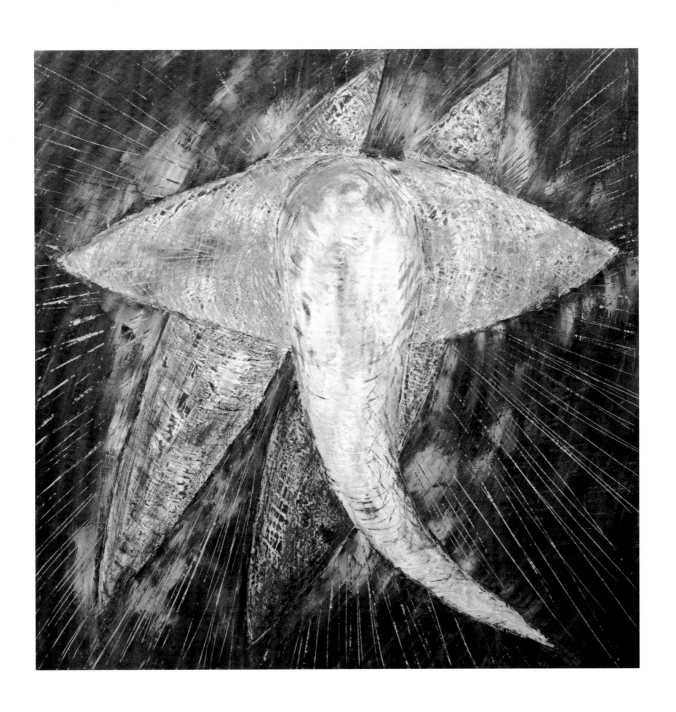

BILL JENSEN

Resurrection, 1978
Oil on linen
22 x 22 (55.9 x 55.9)
Collection of Phil Schrager

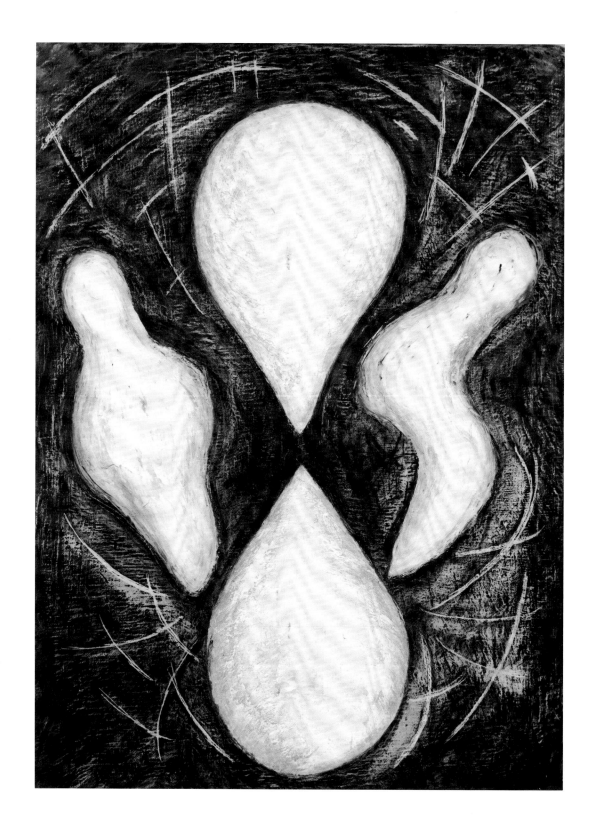

BILL JENSEN

Mute, 1979
Oil on linen
36 x 24 (91.4 x 61)
Collection of Henry and Maria Feiwel

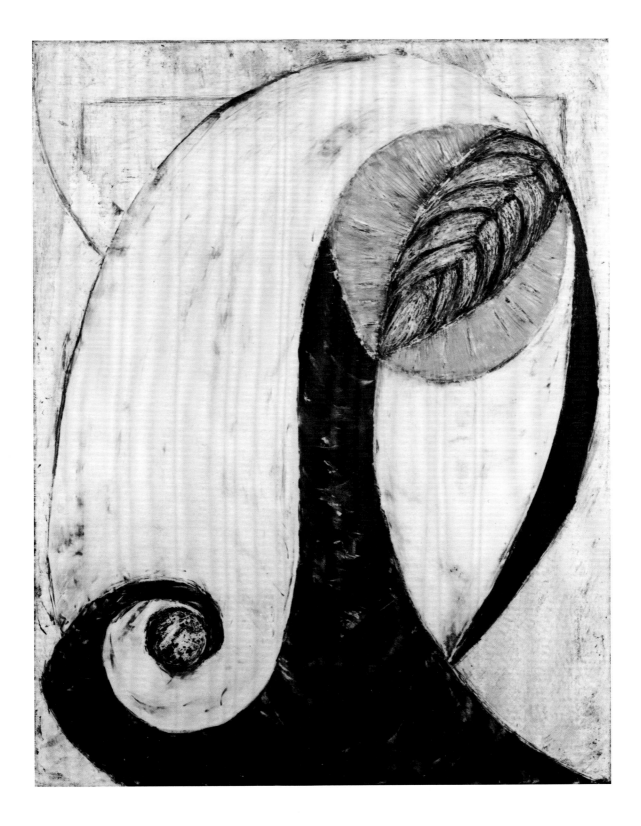

BILL JENSEN

Seed of the Madonna, 1979
Oil on canvas
20 x 16 (50.8 x 40.6)
Collection of Reeds Hill Foundation, Carlisle, Massachusetts

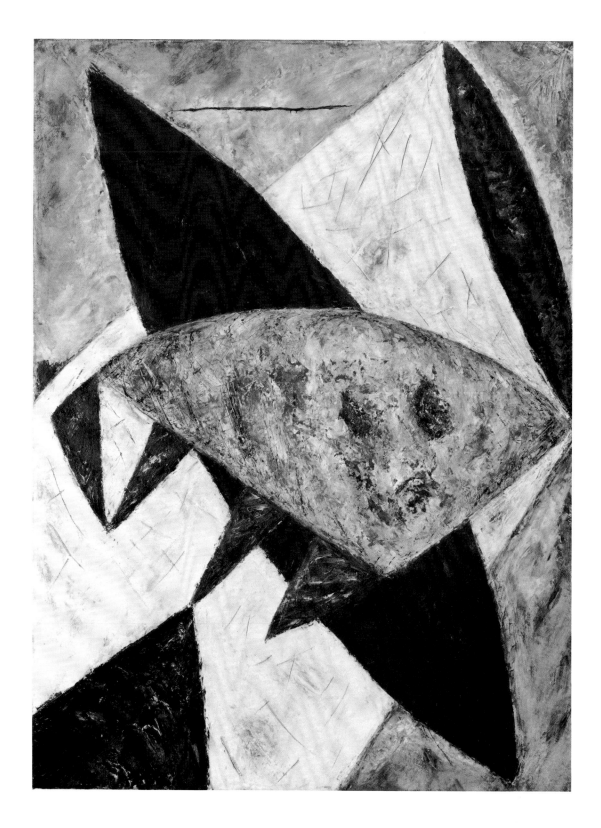

BILL JENSEN

Shaman, 1980–81
Oil on linen
20 x 15 (50.8 x 38.1)
Collection of Mr. and Mrs. Edward R. Hudson, Jr.

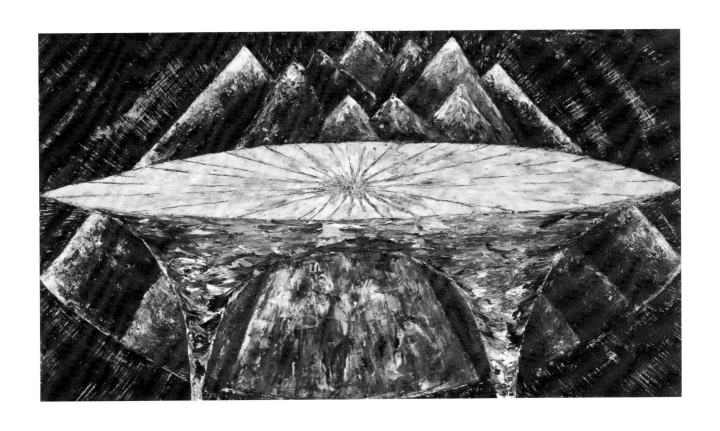

BILL JENSEN

The Family, 1980–81
Oil on linen
20 x 36 (50.8 x 91.4)
Collection of Henry and Maria Feiwel

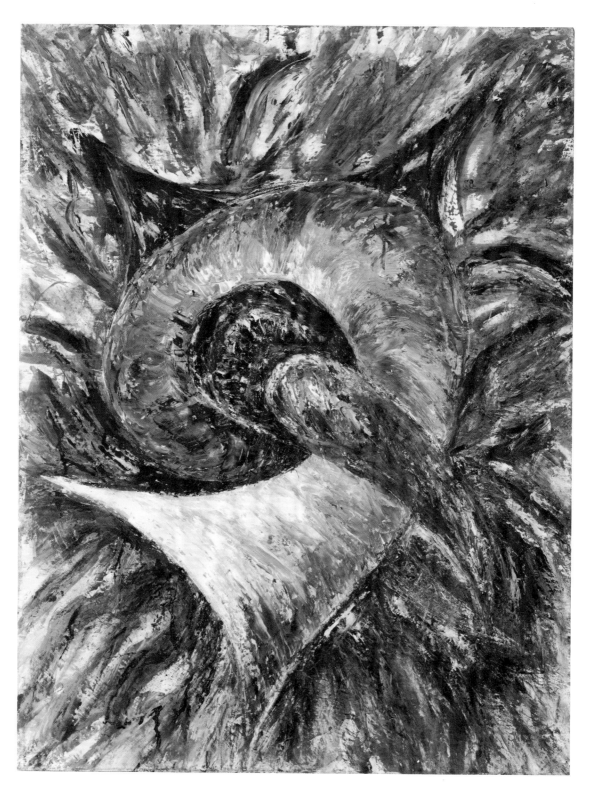

BILL JENSEN

Memory of Closeness, 1981
Oil on linen
26¼ x 20 (66.7 x 50.8)
The Metropolitan Museum of Art, New York; Purchase, Louis and
Bessie Adler Foundation Inc., Gift (Seymour M. Klein, President)

Elizabeth Murray

Elizabeth Murray's development as a painter differs from that of any of the other four artists in this show. She remained a representational painter into the 1970s, then settled on a mature style of abstraction that with time has come to incorporate more recognizable motifs. As her paintings have become more complex, each of their signifying components—touch, color, spatial realtionships, imagery—has grown more assertive. She is responsible for the invention of an abstract, yet highly personal kind of image that was as timely as it has been.fecund; her influential work has come to symbolize the reinvigoration of painting that occurred, largely unheralded, through the second half of the 1970s.

Unlike Davis, Stephan, and Torreano, Murray was an outsider to New York's downtown art scene. She began showing paintings regularly fairly late in the decade (1975), and in the work of the previous five years there is no real affinity for or reaction to any of the touted styles of the day. Even at this point she connected her work, imagistically and by intention, to late nineteenth- and early twentieth-century painting, especially to that of Cézanne and Picasso. "The 'issues' that surround painting," she later explained, "have little relevance to my work. Discussions concerning conceptual vs. minimal art, for example, create a false fog around the act of making art."[1]

This dismissal of certain theoretical concerns in no way detracts from the hard thinking manifested even in the first of Murray's mature paintings, made in 1973–74. These small, heavily worked images have characteristics that continue to distinguish Murray's paintings today: an oil paint surface of charged, patted-on brushstrokes; a combination of loosely geometric, abstract forms with biomorphic ones; and startling disjunctions between the scale of the images and that of the painting.

Murray's work assumes a larger, more public scale and a rapidly increasing assurance in *One or Two Things* (1974), a square divided into a blaring red and a moody aquamarine triangle, their tremulous border punctuated near the picture's center by an orange dot. The tiny dot, overwhelmed by its proportionately endless ground, is the painting's figure. One early reviewer described the effect: "From afar the little figures play about the diagonal line of division between the two areas of color in the painting. From closer up they are revealed as tiny anthill excavations grounded in, more than optically of, the larger surface. That the paintings are an idiosyncratic outgrowth of literalist esthetics is indicated also in Murray's titles. *Two or Three Things* and *One or Two Things* refer to the little figures. Although these paintings lie nominally within a geometric idiom, the unspecificity of these titles connotes growth. There's an animism here that is usually associated with biomorphic abstraction. Just how many 'things' are we dealing with? Will they perhaps proliferate when we're not looking?"[2]

By the time of *Pink Spiral Leap* (1975), those "things" had multiplied considerably, as had Murray's desire to engage larger and larger areas of the ground. Here a dark charcoal gray field, matte in some places, shiny in others, depending on the

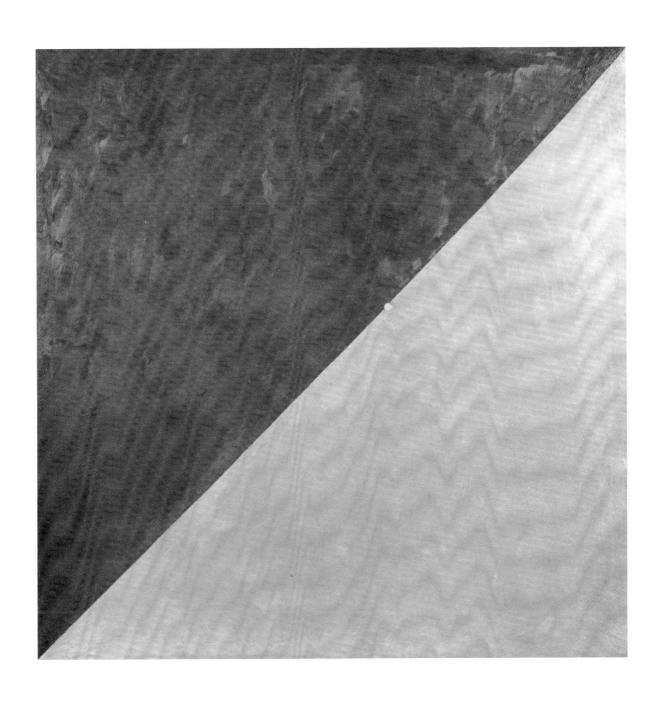

ELIZABETH MURRAY

One or Two Things, 1974
Oil on canvas
72 x 72 (182.9 x 182.9)
Private collection

amount of oil in the paint, holds a pink line that loops awkwardly, then careens off the canvas at the right. Four small squares key the ambiguous space of the calligraphic subject: a blue one serves as the pink line's starting point; another blue sits astride a pink line, showing it as closest to the painting's surface; a third small orange figure hovers at the top edge of the painting above one of the loop's crossings. The fourth dark pink square sits alone at the right, beneath the off-canvas continuation of the loops, suggesting a compositional end to the painting's implied motion. These squares serve as punctuation marks, providing a measure for comprehending the true scale of the paintings—anchoring their associative expansiveness in a quantifiable system. In Murray's later work, other shapes would take on the same function.

The large, somber painting *Beginner* (1976) also employs one of these scale determinants—a miniaturized reconfigured pink spiral. A royal purple biomorphic shape leans to the right of an actively marked gray field, the two colored areas "tied" together with the inconclusively knotted pink figure. The painting was the first to present the bulbous, amorphous shapes that eventually inhabited all of Murray's work.

At once Arp-like in their suggestion of the natural and cartoon-like in their goofy top-heaviness, these forms are portrayed at their colorful best in *Traveler's Dream* (1978). As an initial complication, the square canvas is oriented like a diamond, in the central part of which Murray crowds two of the bulbous forms, one bright pink, the other bright red, into each other. A relatively large, brilliant green-turquoise square deflates this tangle, as usual establishing a measure of scale for the whole picture. A fat black circle closes around all three colored forms, encircling itself on one side by a yellow-on-blue band, on the other by a blue-on-yellow band. The profile of the pink blob recalls its restrained purple forebear in *Beginner*, but here the shape is portrayed as a garrulous and nosy neighbor, poking around in all directions. The madcap coloration of the painting makes it one of Murray's most unabashedly joyful. Its jostling, seemingly incompatible compositional components are cleverly orchestrated: the circular framing devices keep bringing stray parts back into the center of the picture while softening its exiled corners.

Parting and Together (1978) is a related painting, though its composition is altogether different. Again, Murray tilts the canvas, here forming a long parallelogram. A curving black shape lies on top of a larger, pink one. The eye is almost forced into the corners of this painting: first by an exploding, jagged green field that pushes out from the layered figures only to be overlapped by magenta shards on all sides, and then more forcefully by an Art Deco lightning bolt that courses a stylized path from one corner to another. At each end this line is anchored by a glowing red dot. The painting exemplifies the "dandyish abstraction" Donald Kuspit perceived in Murray's work: "Murray, as it were, proves Camus' point that 'dandyism is a degraded form of asceticism'—she gives us a degraded and thereby enlivened, freshly expressive, formalist purity." Noting her work's historicism—he finds borrowings from Malevich to Noland—Kuspit concludes, portentously: "There is above all an over-consciousness of the medium, if that is possible, in the sense that planarity and touch at times seem to matter more than the limits and shape of the individual plane and the kind of touch—just that which gives them their particularity."[3]

Murray's use of "sources" may not be as wide-ranging as Kuspit maintains. She seems to limit her quotations to early European abstraction, especially that of Arp and Kandinsky. Because of these references, she appears to be an unusually self-conscious

ELIZABETH MURRAY

Pink Spiral Leap, 1975
Oil on canvas
78 x 76 (198.1 x 193)
Collection of Lewis and Susan Manilow

painter—a trait shared by most of her peers. Indeed, much of the widespread interest her paintings generated among other artists was due to their obvious struggle to overcome that self-consciousness. Her smaller and simpler early paintings represent only the first steps in finding images that could acknowledge their origins in modern art in a meaningful, empirically derived way. The initial reticence and awkwardness of Murray's paintings were treasured signs of their authenticity.

Sometime in 1980, representational imagery, mostly artifacts from her studio, supplanted the biomorphic balloons as Murray's principal subject. In the same period, she began to physically fracture the canvas. With this device Murray could make real and heighten the growing tension she sensed between the abstract and the representational aspects of her paintings: simply put, she could impose real imagery on an abstract, fragmented ground. *Art Part* (1981) is the most fragmented of these paintings, an archipelago of small canvases. The shattered imagery is of a loaded, dribbling paintbrush resting on a five-fingered green hand.

In the works that followed she experiments more with the real spaces between the canvases and with a moodier, less fantastic palette. In *Fly By* (1982), four rectilinear canvases are staggered and stacked in a literal re-creation of the jaggedly stepped lines of the earlier Art Deco–like paintings. An upside-down goblet spilling blue liquid makes its way across all four surfaces. Red shafts connect to one painted plane, suggesting the skewed legs of a table, as comparable gray shafts connect to another, all forcing the eye back and forth across the four integrated planar surfaces of the canvases. The intense application of a dark ground at the left tapers off toward the bottom corner of this canvas, revealing the painter's process. A spectrum of weightier colors—mustard yellows, red, black, slate gray—suggests a different historical value: to Murray they evoke recollections of the still lifes of Cézanne, even of Chardin.

Images join and sometimes overlap in the three distinctly shaped canvases of *Sentimental Education* (1982), directing the eye from one part of the painting to another. It features a large, jagged, almost figurative black canvas at the left, touching a modeled yellow-greenish comma-shaped canvas. This in turn supports an oddly curved and scalloped blue shape that wraps around an outstretched arm of the black figure. Across the blue cavorts a chain of red ellipses, dipping into the comma and pushing, more timidly, into the neighboring black at two points. The comma's curlicue gives rise to a pink line that kinks its way across the black to the top of the painting and, broken, into its far left side and bottom corner. The line, like those of the earliest paintings, seeks to reintegrate separated areas of color. Murray by now is far beyond *One or Two Things*.

The coffee cup, another much favored still-life element, has its most magnified incarnation in the large painting *Yikes* (1982). Two roughly interlocking shapes—rounded on the outside to conform to the coffee cup imagery, cut on the interiors to make the now familiar jagged and bulbous silhouettes—tentatively poke at each other at three points. Blue coffee splashes out of the giant red coffee cup. The title can be read as the artist's exclamation: she has achieved here a large and relatively simple synthesis of shape to image and reduced her two preferred forms into a negative space. A somber painting, *Yikes* also clearly summarizes Murray's activity to this point. It implies a specific location for the subject—on a saucer and surrounded by aromatized air—and so foretells the increasingly representational tone of Murray's subsequent work. In *Deeper than D* (1983), she introduces a chair, yet another still-life component. Here she compounds the eccentric, complicated, and torqued planar space of the shaped

canvas with a space at least sufficiently deep to accommodate the chair, which is enclosed by walls on three sides. Starting in the early 1970s with a simple, almost primitive, abstract vocabulary, Murray now seems ready to submit visual "reality" to her unique scrutiny. She has turned outward.

1. Quoted in Barbara Rose, *American Painting: The Eighties: A Critical Interpretation*, exhibition catalogue (New York: The Grey Art Gallery and Study Center, New York University, 1979), unpaginated.
2. Alan Moore, in "Reviews," *Artforum*, 13 (April 1975), pp. 82–83.
3. Donald B. Kuspit, "Elizabeth Murray's Dandyish Abstraction," *Artforum*, 16 (February 1978), p. 30.

ELIZABETH MURRAY

Beginner, 1976
Oil on canvas
113 x 114 (287 x 289.6)
Collection of Doris and Charles Saatchi

ELIZABETH MURRAY

Traveler's Dream, 1978
Oil on canvas
102½ x 87 (260.3 x 221)
University Gallery of Fine Art, Ohio State University, Columbus;
Puchased with funds from the National Endowment for the Arts
and the Ohio State University Development Fund

ELIZABETH MURRAY

Children Meeting, 1978
Oil on canvas
101 x 127 (256.5 x 322.6)
Whitney Museum of American Art, New York;
Gift of the Louis and Bessie Adler Foundation, Inc.,
Seymour M. Klein, President 78.34

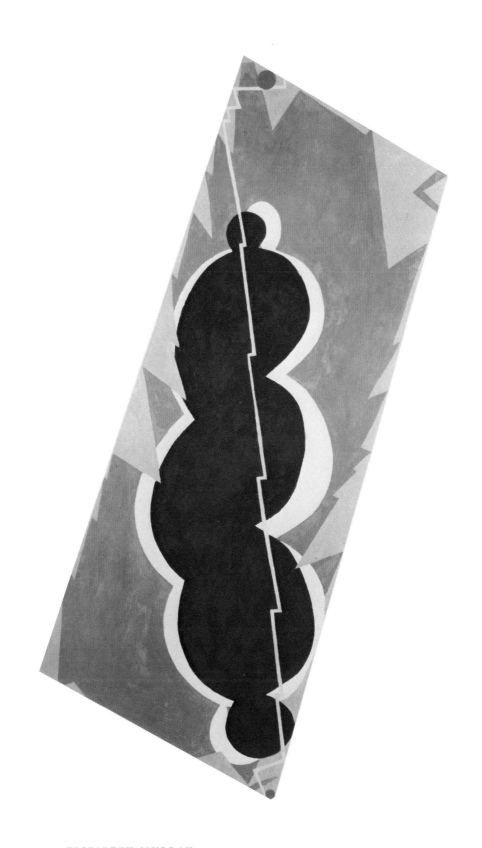

ELIZABETH MURRAY

Parting and Together, 1978
Oil on canvas
122 x 52 (309.9 x 132.1)
Collection of Mr. and Mrs. Paul Anka

ELIZABETH MURRAY

Art Part, 1981
Oil on canvas
115 x 124 (292.1 x 315)
Private collection

ELIZABETH MURRAY

Fly By, 1982
Oil on canvas
106 x 76 (269.2 x 193)
Collection of Mr. and Mrs. Marvin Gerstin

ELIZABETH MURRAY

Sentimental Education, 1982
Oil on canvas
124½ x 86 (316.2 x 218.4)
Collection of Michael and Judy Ovitz

ELIZABETH MURRAY

Yikes, 1982
Oil on canvas
116 x 113 (294.6 x 287)
Collection of Douglas S. Cramer

ELIZABETH MURRAY

Deeper than D, 1983
Oil on canvas
106 x 102 (269.2 x 259.1)
Private collection

Gary Stephan

Gary Stephan returned to painting on canvas in 1973 with a series of shaped paintings of monochromatic images that corresponded to the overall configuration of the picture plane. Cool, spatially ambiguous, often confounding presentations of figure-ground relationships, the paintings acknowledge the development of Stephan's visual logic. In 1967, after completing graduate school in San Francisco, Stephan had come back to New York because he was attracted to the Minimalist work that dominated the New York art scene. But once here he found himself disinclined to conform to the precepts of the style. Instead, he constructed two groups of highly nuanced pictures—the first in paint-tinted polyvinylchloride, the second in assemblages of painted wood, masonite, and metal. Both sets integrated their armatures into their imagery, the assemblages inseparably so. The plastic paintings were elaborate pictorial constructions, the assemblages, objects with pictorial aspirations. In their final incarnation (1972), these assemblages became small, flat, eccentrically shaped empty frames that incorporated into the picture the negative space of the supporting wall.

The 1973 shaped canvases were, ironically, elegant if quirky interpretations of the waning Minimalist style. In paintings such as *Chinatown* (1973–74), stark, impersonally applied geometric fragments join or not on a field of painted jute cloth that has been geometrized by shaped stretcher bars. The combination of the deliberately uninflected subjects and the non-allusive coloration of both figure and ground makes these works the most restrained in Stephan's art; in retrospect they can be seen as a self-imposed purification and refinement of earlier work in preparation for paintings that would, eventually, become as illusionistically rich as his work of the late 1960s and early 1970s had been.

The Garden Cycle paintings, such as *Untitled* (1975), which Stephan worked on next, re-engaged figure-ground questions, but in a considerably more personalized way. In each of them, thin washes of evocative color define a puzzling shape in a surrounding field. The centralized, oddly geometric form touches the painting's edge at some point, grounding the image and breaking its confinement. That the series title alludes to a geographic locale suggests that they are best read as cartographic images—about enclosure, territorial definition, and the transgression of boundaries. They may have been recollections of spatial concerns Stephan had observed while working as a studio assistant for Jasper Johns when the latter repainted his 1969 version of Buckminster Fuller's Dymaxion map; in any case, they have a more frankly intuitive sense to them than the shaped paintings and are the first and simplest of Stephan's painterly paintings.

The much larger scale of such works as *Natural Language—September* (1978), its unhesitant brushiness and richly poetic color, makes it an ambitious successor to the Garden Cycle paintings. Comparable, eccentrically rectangular shapes, cut into and rounded off, are again the subject, but now Stephan is full into the layered, greatly

GARY STEPHAN

Chinatown, 1973–74
Oil and acrylic on jute
89 x 108 (226.1 x 274.3)
Collection of the artist,
Courtesy Mary Boone Gallery, New York

GARY STEPHAN

Untitled (from the Garden Cycle), 1975
Acrylic on canvas
44 x 44 (111.8 x 111.8)
Collection of the artist,
Courtesy Mary Boone Gallery, New York

worked over and drawn paint applications that would continue to characterize his paintings. It was about this work that Robert Pincus-Witten, Stephan's most enthusiastic critic, observed: "At this moment, Stephan's characteristic impasto, a build of graduated crust along a slightly scored edge, becomes quite incisive; equally marked is his still somewhat apologetically adduced historicist iconography and associative color."[1]

In the large group of alchemy-titled paintings that followed, including *Master—Quicksilver* (1980), Stephan at once expanded his iconography by using strongly illusionistic charcoal drawing to set up anthropomorphic structures, and he adopted a more artificial, tonally disparate palette. *Master—Quicksilver*, with its overlay of charcoal lines and giddy mauve patches atop a thin yellow ground, is the most light-filled of the lot. The vertical format of the paintings suggests a representational reading of the drawing in them, but Stephan often seems to use color, as in *Master—Quicksilver*, to deny such readings. Certainly, the mauve of this painting reasserts the work's fundamentally abstract nature.

The drawing in all these paintings alternately punches back and torques the picture plane with increasing ferocity and conviction. In choosing alchemical titles, Stephan appears to fully acknowledge the fictive powers of painting—its power to change by various illusions base materials into visual analogues of thought and related sensate data.

Both Stephan's unusually adept drawing skills and his brassy modern palette owe much to his early training as an industrial designer at Pratt Institute. His own pronouncements about art betray a pragmatic, materialist approach to painting that probably stems from his design school days: "Paintings do something. Like cars, they do something. And the 'doing' is perceptual and neural. Paintings operate. Something happens. That is why painting is a radical activity."[2]

The figurative connotations of his newfound upright subjects were not lost on Stephan. Around 1980 he began in earnest to employ a repertoire of tubular forms, what he calls "torso-shapes," to produce the complicated interplay of flat, convex, and concave spaces which are characteristic of all his mature work.

Bells and Thought (1981) is one of the fullest early examples of the rounded-out space Stephan was developing. A remnant of the former figure-ground device appears to establish a ground at both the right- and left-hand side of the painting. But a cluster of slightly tilted cylindrical, conical, and bulbous forms shatters the static linear composition common to the earlier paintings. *Bells and Thought* is a perplexing painting for its muddled, unresolved spatial qualities—it is almost as if Stephan denies more space in the painting than he asserts. But in its dependence on rounded, almost rotating illusionist mass, it foretells nearly every subsequent painting. Likewise, one of its more troubling and "unsuccessful" elements—the flat, blue spoon-like form obscuring the white plane at the top right—operates as a key to the undeniable two-dimensionality of the painting. Other such keys, self-induced admissions to the illusory nature of Stephan's art, are to be found in many of his best paintings.

Oh Ye of Mental Men, a closely related, more legible painting of the same year, sorts out and repositions the conflicting and partially realized forms of *Bells and Thoughts. Oh Ye of Mental Men* makes apparent how quickly Stephan had come to terms with his recently discovered "torso-shapes" and their ambient spatial requisites. Here, massive tubes push up from the bottom center of the picture, making a three-

pronged cone. A black concave fragment to the left of the center pole establishes the painting's tactile depth, finding an echo in a dark concavity gorged into the right pole. A spectrum of atmospheric blues, thickly painted at the top of the cone, washes down toward the left side of its apex, violating the integrity of the pole on that side. This is the kind of move that must have prompted Carter Ratcliff's early observation that Stephan's work "presents impediments to the eye," an insight he later expanded, pointing out that some of Stephan's more recent works "build all their cues to volume from aggressive manifestations of flatness."[3]

With quickening assurance, Stephan enlarged the scale and illusions of his painting, as well as their color. (He occasionally returned to "shaped" canvases—in some of his multipaneled paintings components project at different lengths.) The brightly painted and almost reversible imagery and shaped canvas of *Sator/Arepo/Tenet/Opera/Rotas* (1982) evinces Stephan's efforts to accentuate spatial qualities. He works to create a visual counterpart to the multidirectional palindrome of the title (a word puzzle used as a secret recognition sign by Early Christians) to make a balance between background and foreground, and left and right, that keeps the whole animated and visually engaging.

Other more recent paintings such as *The Brazen Serpent of Moses* (1982) and *The Rules of Appearance* (1983) overtly hark back to Stephan's early painted wooden constructions by incorporating negative space into the painting's imagery. In *The Brazen Serpent of Moses*, a floating cone is cut through by stretcher bars, whose tension-adjusting bolts are prominently displayed, thus denying the illusory, in favor of the real, qualities of the wood. The truncated cone and the short pyramid-shaped bar that joins into its apex recede, suggesting a "deeper" reading of the painting. But the three grayish vertical planes which form the picture's background offer little further information; as pictorial elements, the exposed stretcher bars and two wood strips that flank the painting offer none. As Ratcliff suggests, "Here Stephan confronts the actual with the fictive, then renders portions of the fictive actual, which is to leave all such labels in a vexed state—what is one to call a carefully finished piece of wood after it has locked in with Stephan's passages of painted geometry?"[4]

Similar questions are provoked by *The Rules of Appearance*. It is a narrow, three-panel painting, the central part of which is also a set of stretcher bars, this time separated and beveled back to the exposed wall. Part of a large cone flops across the naked stretcher, bridging the unreal outer parts of the painting across the real. Tacitly, then explicitly, incorporating these negative spaces into the paintings underscores their connection with Stephan's wood assemblages of 1972. Both the early and the later work share an emphasis on planarity, on volume-enhancing color and eccentrically shaped voids—their spatial constructs, which derive from Cubist models, are the same, evolved over time.

Certain recent paintings, such as *Mental Value* (1983), enrich Stephan's highly developed figure-ground relationships by, in effect, imposing one such set on another. The paintings' spatial ambiguities are thus enhanced by an equally ambiguous treatment of its subjects: meanings shift back and forth between images that alternately dominate, then are subordinate to one another.

In *Mental Value*, for example, three joined oblong panels abut the sides and bottom of a large rectangle that protrudes at the top from the flanking oblongs. The ground colors of the three are all darker than that of the light blue-gray center panel, which in

addition has been treated with a water corrosive to make a stippled, luminous surface. The two outer panels each support the image of a cone, halved by the superimposed light blue panel. The images join around a curious, semicircular void in the horizontal bottom panel. A small orange and purple cone, its exterior colored to re-form part of the obscured neighboring cones, hovers on the blue stipple. Stephan's inversions and complex revelations of concavity and convexity take on a new authority here. His long-standing commitment to non-figurative illusionist art, nurtured first through a period hostile to the inherent allusiveness of his imagery, and more recently through a period of unfettered subjectivity, distinguishes Stephan's empirical abstractions. We sense in them a welcome ambition, not of ego, but of vigorous visual imagination and intelligence.

1. Robert Pincus-Witten, "Gary Stephan: The Brief Against Matisse," *Arts Magazine*, 56 (March 1982), p. 136.
2. Quoted in Pincus-Witten, p. 133.
3. Both passages cited appear in Carter Ratcliff, *Fact and Fiction*, exhibition catalogue (New York: Tibor de Nagy Gallery, 1984), unpaginated.
4. Ibid.

GARY STEPHAN

Natural Language—September, 1978
Acrylic on canvas
72 x 54 (182.9 x 137.2)
Collection of William J. Hokin

GARY STEPHAN

Master—Quicksilver, 1980
Acrylic on canvas
88 x 53 (223.5 x 134.6)
Collection of Helen N. Lewis and Marvin B. Meyer

GARY STEPHAN

Bells and Thought, 1981
Acrylic on canvas
108 x 72 (274.3 x 182.9)
Collection of Dupuy Warrick Reed

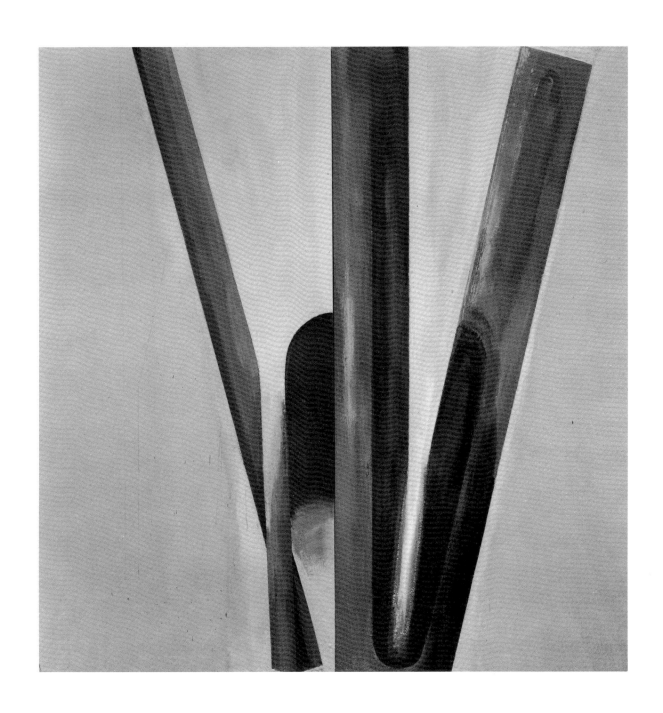

GARY STEPHAN

Oh Ye of Mental Men, 1981
Acrylic on canvas
96 x 96 (243.8 x 243.8)
Collection of Barbara and Eugene Schwartz

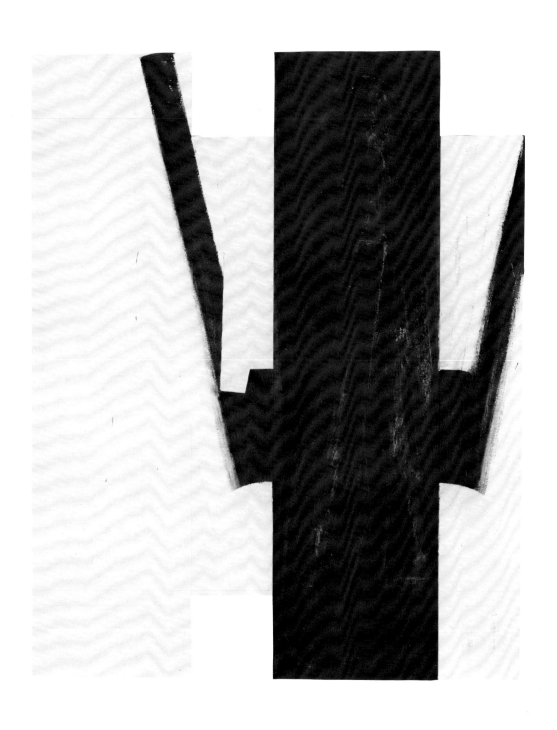

GARY STEPHAN

Lights, 1982
Acrylic on canvas
90 x 72¼ (228.6 x 183.5)
Collection of Pamela and Arthur Sanders

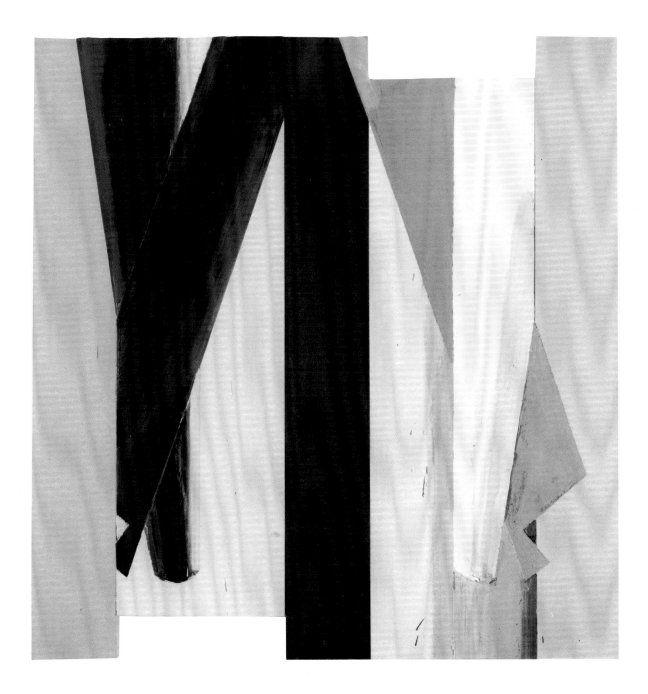

GARY STEPHAN

Sator
Arepo
Tenet
Opera
Rotas, 1982
Oil on canvas and linen
89 x 84 (226.1 x 213.4)
The Metropolitan Museum of Art, New York; Purchase,
George A. Hearn Fund, and Eugene M. Schwartz, Gift

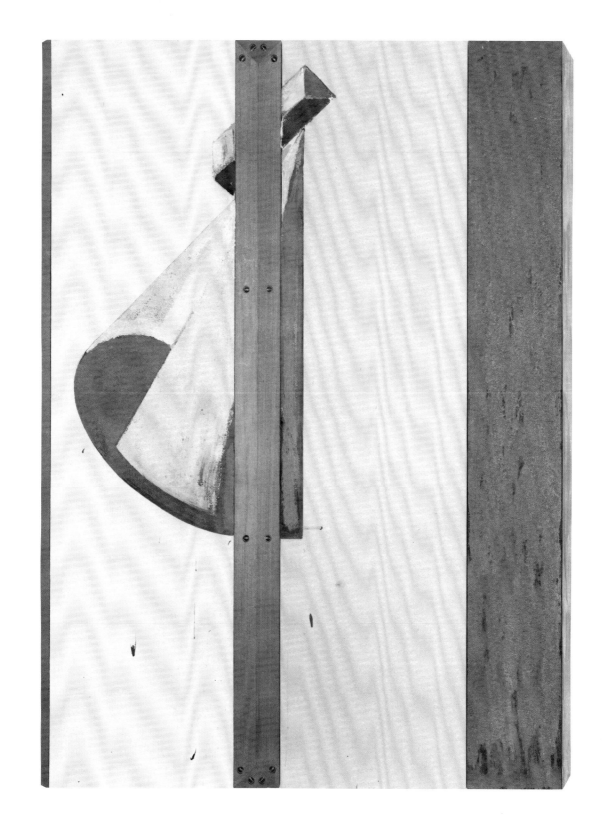

GARY STEPHAN

The Brazen Serpent of Moses, 1982
Acrylic on linen and muslin, wood
96 x 71 (243.8 x 180.3)
Collection of Adrian and Robert E. Mnuchin

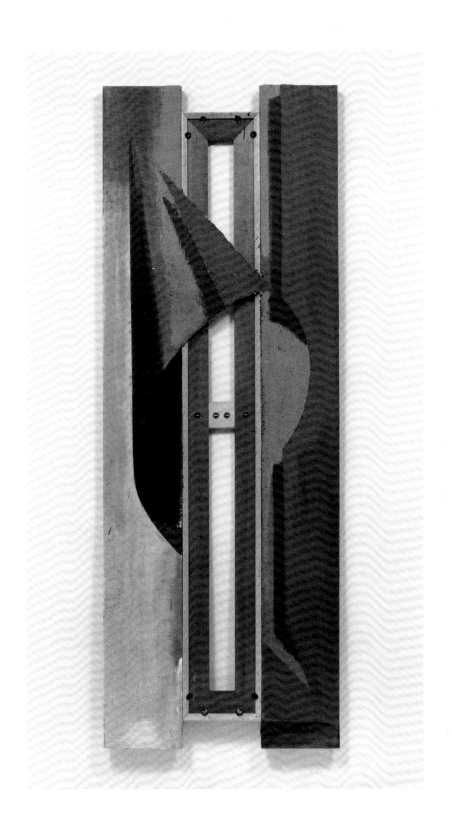

GARY STEPHAN

The Rules of Appearance, 1983
Acrylic on linen, wood, and styrofoam
86 x 31½ (218.4 x 80)
Mary Boone Gallery, New York, and
Margo Leavin Gallery, Los Angeles

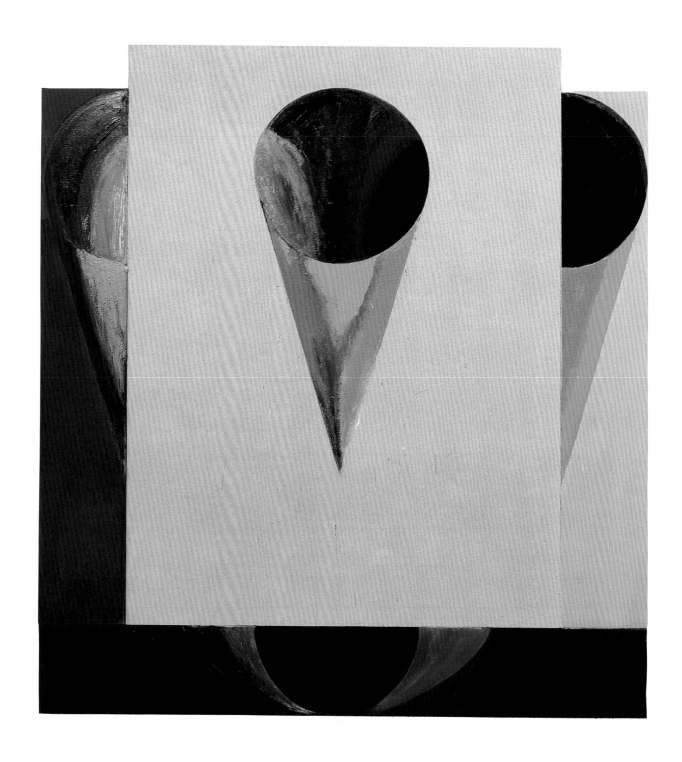

GARY STEPHAN

Mental Value, 1983
Acrylic on canvas and wood
90 x 84 (228.6 x 213.4)
Mary Boone Gallery, New York, and
Margo Leavin Gallery, Los Angeles

John Torreano

The first paintings John Torreano made after coming to New York from Detroit in 1968 were a series of tondi in which perimeter-to-perimeter white grids overlay a thinner, multicolored grid. He now characterizes these paintings as "my idea of painting a Dan Flavin on a plaid ground,"[1] and the paintings do have strong retinal after-images something like that induced by Flavin's Minimalist fluorescent sculpture. The comment reflects Torreano's recollection of the ascendant powers of Minimalist art during the 1960s and his incipient concern with light as a physiological reality and as a metaphor for the perception of art. That he would willingly assign values he saw in sculpture to his paintings is noteworthy, too, since the movement in Torreano's oeuvre alternates between two- to three-dimensional objects. He has forced a hybridization of the complementary disciplines of painting and sculpture.

The lyrical abstract paintings which followed these tondi formed obvious spatial illusions with their free-form paint dots floating in a large, highly gestural field of thinly applied paint. But he soon wanted to test the randomly scattered dots of these paintings against a more externalized reality: he began looking at photographs of star formations, searching for compositional similarities to his own work. The abstract fields of his paintings retrospectively assumed meaning as galaxies, and he discovered that glass jewels offered a good and physically attractive translation of the star-dots. First employed as isolated light sources within a larger painted field, the jewels eventually so overpowered the paint that by the end of the 1970s they alone decorated Torreano's sized canvases and bare wooden supports. Over a period of ten years paint was subordinated until it almost disappeared.

Although his work is among the most physically bizarre of the past decade, it is also among the most conceptually generated. Torreano, much like the linguistic Conceptualists, has sought to catalyze a self-critical interaction between art object and viewer —they with words, he with plastic media. His means have been distractingly literal, the common glass jewel foremost among them. And it is the jewels themselves that have suggested the physical formats of everything he has made. Through all these formal permutations his subject has remained the nature of perception.

The faceted, reflective planes of the jewels in combination with the optical mix of daubed-on paint (used as much as a binding agent as a coloring one) creates an *a priori* pointillism in all of Torreano's work. An attraction to this procedure—in an updated version—was surprisingly widespread among Torreano's peers: Nancy Graves (in her drawings and paintings only), Jennifer Bartlett, Chuck Close, and Joe Zucker, among others, were also exploring variations of it. While Close, and to a lesser extent Bartlett, pursued their course with relatively orthodox materials and images, Zucker and Torreano chose to question not only the compatibility of the style with unusual imagery, but also its inherent physical possibilities—Zucker with his rhoplex-stiffened cotton balls, Torreano with his jewels. In both instances the artists deconstruct modernism's

JOHN TORREANO

Big Red, 1974
Oil and glass jewels on canvas
60 x 60 (152.4 x 152.4)
Collection of Susan and Bill Pigman

JOHN TORREANO

Split, 1976
Oil and glass jewels on canvas
48 x 168 (121.9 x 426.7)
Collection of Fred Mueller

concern for facture, for the signifying touch of the artist, in a preposterous, satirical magnification.

All the 1970s pointillists share a fundamental need to employ recognizable imagery that is filtered through a desire to structure that imagery, however irrational it might itself be, as rationally as possible. Thus each began by superimposing the smallest structural component of the chosen image, the mark, on a grid—the simplest symbol of their common visual legacy of the 1960s. Torreano's is the most liberal adaptation of the style, as he rarely used grids to transfer imagery from one scale and medium to another. But in turning to star maps for inspiration and external confirmation of his imagery, he implicitly makes use of gridded, cartographic systems.

The earliest painting included here, *Big Red* (1974), is a fully resolved integration of jewels into a highly atmospheric ground reminiscent of Torreano's lyrical abstractions. A variety of colored jewels animates the gestural red-white ground, and white paint dots coexist as star signifiers with the jewels. The painting, like all of Torreano's until very recently, is on rounded stretcher bars that gently curve into the wall, an echo of the stepped planes of the jewel cuts.

In the Columns series he began about this time, and which occupied him off and on over the next few years, the rounded stretcher bars themselves become a naked armature. They are the most concise manifestation of Torreano's search for a physical analogue to deep space, an effort he continued to sustain by research into stellar photography. Jeremy Gilbert-Rolfe noted that in the Columns series, Torreano "seems to have found a format which is responsive to the optical capacity of the deep color that he employs to pull you into the pictorial space. The fluid continuity of the edge responds to the movement into the space of the painting that's suggested by the color, and this gives the diamonds something to do. . . . When the paintings are curved, too, the whole feeling of uncertainty that is communicated by a color that retreats from the eye in the absence of a perimeter that pins the painting to the wall, and which seems to me to be the subject of Torreano's work, gives meaning to the plastic diamonds. One looks around them at the surface, but as one does they become possessed by that surface— into which they are physically inserted—and begin to float back into a more ambiguous space, a space that can't help but suggest the night sky."[2]

That same year, 1975, Torreano went beyond suggesting stellar qualities and galactic space by making an installation of jewel-encrusted spheres that was in effect its own little galaxy. These *Universe Paintings*—paint- and jewel-covered balls varying in diameter from 6 to 15 inches, filled a corner of a gallery space. Whole paintings hung by wire at different distances from the ceiling, while some rested on the floor, and other, partial spheres protruded from the enclosing walls. Seen this way, the *Universe Paintings* are Torreano's most dramatic representation of deep, real space. Although the installation had its light-hearted aspects, Torreano was dead serious about creating multiple foci to produce a non-hierarchical reading and shifting perspectives. To be seen wholly these spherical paintings compel movement, just as the more planar work, studded as it is with jewels, implies an infinite wealth of surface information if only the viewer move: with changing vantage points different facets of the jewels reveal themselves, while others fade into relative opacity.

The unusually large diptych *Split* (1976) is the most grand of Torreano's completely abstract paintings. The 7-foot-long left side, painted cadmium red and randomly bejeweled, abuts a slightly larger bejeweled green side. The color does not

relate to stellar space or atmosphere. Almost complementary, the two tones are meant to tighten the join of their panels. The seam between the fields underscores their physical disjunction, but the two halves embody similar jewel-to-paint ratios. Their coloration signals the fundamental dichotomy of Torreano's chosen media with his purposes: looking *at* is provoked by the glittering physicality of the jewels, looking *in* by their illusive and highly reflective capabilities. The painting's endlessly allusive spaces evolve from their unorthodox materials.

In the three years following *Split*, Torreano worked through at least two sets of paintings. In one he enriched the dramatically deep space inherent in the more gestural paintings like *Big Red*, while in the other he formulated a set of abstract variations of *Split*. Among the latter are *Grapes* (1979), *Medal* (1979), and *Irish Cousin II* (1980). All 6-foot square, the paintings vary in jewel density, but very little paint is used in any of them as Torreano goes about suggesting different spatial depths, thereby altering distances between the audience and the painting. The deliberately unfathomable depths of a painting like *Big Red* are reversed in the distant, but visually impenetrable skin of *Grapes*. A mass of swarming black jewels obscures the canvas, and many nearly congealed vortices imply ferocious motion across its surface. A comparable but less dense arrangement of jewels makes *Medal* a closely related painting. Clusters of jewels are scattered over the face of the painting—at the ready for some energetic catalyst to set them into the feverish motion of *Grapes*.

With its expanded palette of red, green, blue, pink, and translucent jewels, *Irish Cousin II* is a final reprise of Torreano's more abstract pointillist paintings. Gooey daubs of white paint and white glue bind jewels to canvas and jewels to jewels. Occasionally, paint obscures jewels in a momentary triumph over the flashy, domineering bits of colored glass.

Torreano's paintings on canvas of the last few years have become more representational. Both *Orion* (1981) and *Crab Nebula* (1980) revert in technique to a more straightforward pointillist method, mixing large areas of jewels with more opaque and defining points of paint. Each refers to the stellar phenomenon it is named after. It is as if thousands and thousands of Torreano's *Universe Paintings* have been miniaturized, each to make one dot in these enormous galactic occurrences.

Never one to repress seemingly conflicting ideas, Torreano developed a populous suite of wooden cross paintings while working on the large constellation paintings. The shape suggested itself to him for two reasons: first as a logical complication of the earlier columns; second, and more impetuously, because one of his favorite constellations, Pleiades, forms a cross when seen from other galaxies. The significance of the cross as the principal symbol of Christianity no doubt also appealed to the lapsed Catholic in Torreano.

His treatment of this newly configured wooden armature resembles that of the contemporaneous paintings. The thin, equidistant arms of *Irish Cross* (1981), for example, are smothered in a crust of paint, glue, and colored jewels. As with *Irish Cousin II*, the paint alternately receives and obscures the glass pieces. By contrast, the larger *Crystal Cross* (1982) seems unpainted—or better, untouched by paint. For as the jewels in this final cross so elegantly insist, they must always be seen as paint surrogates. Here Torreano has routed small receptacles out of the wood in order to fill them in with glue-backed crystal jewels.

Amethyst Group (1983) is one of several recent paintings that exclude actual

jewels for the first time in almost twelve years. Portraits of jewels, derived from microphotographs of gem stones, these paintings are rendered with a thin water-color-like application of acrylic paint. Here four stones lie on an imaginary plane, their faceted sides defined by wide swatches of black and purple paint. Odd white areas make up the spaces between the jewels as well as represent gleams of light reflected off them. It is the omnipresent light which illuminates Torreano's jewel-universe in a perpetually changing revelation. Illusions abound, and beauty shines forth in all directions.

1. Quoted from a talk given by the artist at the Independent Study Program of the Whitney Museum of American Art, New York, October 12, 1983.
2. Jeremy Gilbert-Rolfe, in "Reviews," *Artforum*, 12 (June 1974), p. 69.

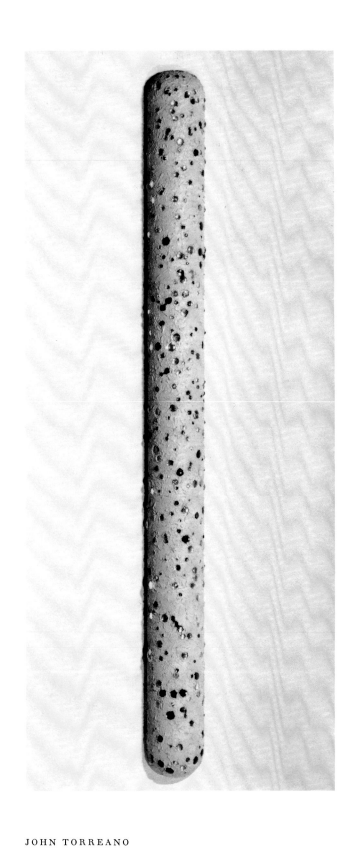

JOHN TORREANO

Column, 1975
Oil and glass jewels on wood
96 x 8 (243.8 x 20.3)
Collection of Mr. and Mrs. Boyd Mefferd

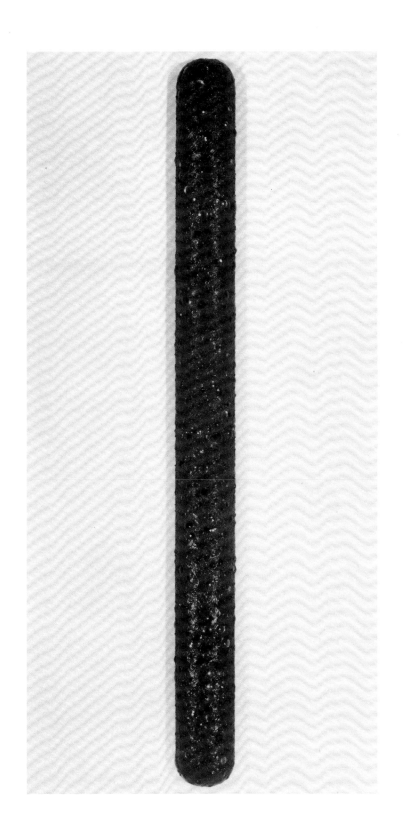

JOHN TORREANO

Column, 1975
Oil and glass jewels on wood
96 x 8 (243.8 x 20.3)
Collection of Doris and Charles Saatchi

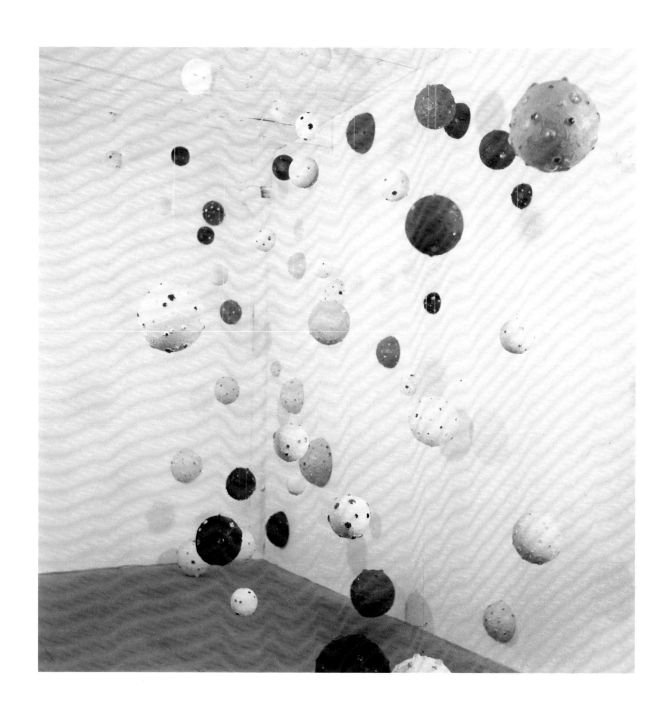

JOHN TORREANO

Universe Paintings, 1975
Oil, acrylic, and glass jewels on wood and
polyester spheres, dimensions vary from
6 to 15 (15.2 to 38.1) diameter
Collection of the artist

JOHN TORREANO

Medal, 1979
Acrylic and glass jewels on canvas
72 x 72 (182.9 x 182.9)
Collection of the artist

JOHN TORREANO

Grapes, 1979
Acrylic and glass jewels on canvas
72 x 72 (182.9 x 182.9)
Collection of Phil Schrager

JOHN TORREANO

Irish Cousin II, 1980
Acrylic and glass jewels on canvas
72 x 72 (182.9 x 182.9)
Collection of Gloria and David Leader

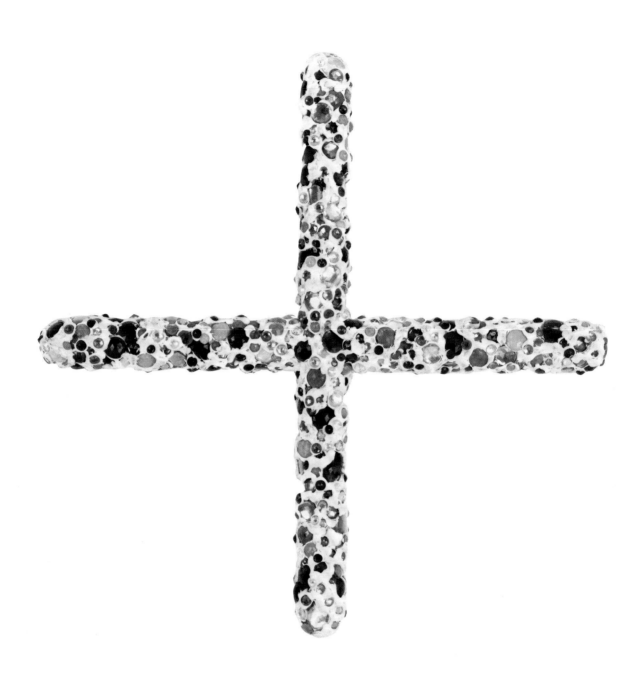

JOHN TORREANO

Irish Cross, 1981
Acrylic, silicon glue, and glass jewels on wood
31½ x 31½ (80 x 80)
Collection of Martin Sklar

JOHN TORREANO

Crab Nebula, 1980
Oil and glass jewels on canvas
84 x 84 (213.4 x 213.4)
Collection of Camille and Paul Oliver Hoffmann,
courtesy Rhona Hoffman Gallery, Chicago

JOHN TORREANO

Orion, 1981
Acrylic and glass jewels on canvas
102 x 84 (259.1 x 213.4)
Private collection

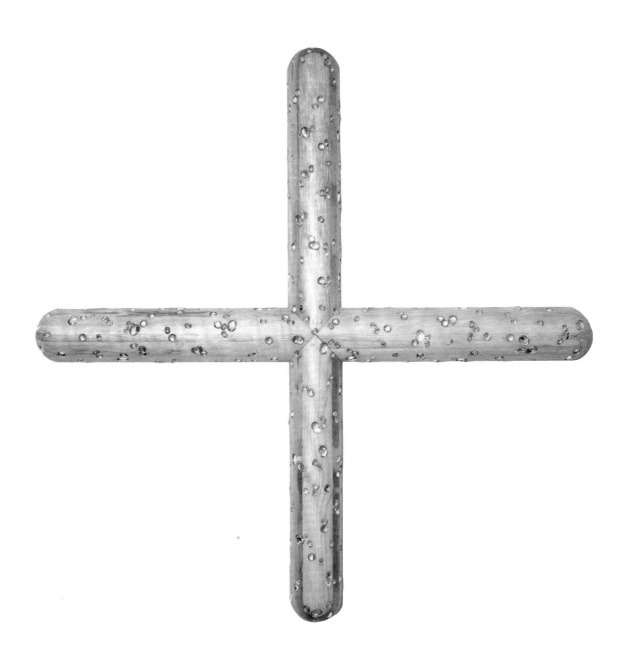

JOHN TORREANO

Crystal Cross, 1982
Glass jewels on wood
84 x 84 x 8 (259.1 x 259.1 x 20.3)
Collection of the artist, courtesy Susanne Hilberry Gallery,
Birmingham, Michigan

JOHN TORREANO

Amethyst Group, 1983
Acrylic on canvas
84½ x 66½ (214 x 168.9)
Collection of the artist

Brad Davis

Born in Duluth, Minnesota, 1942

Studied at the University of Chicago (1961–62);
School of The Art Institute of Chicago (1962–63);
University of Minnesota, Minneapolis (B.A.,
1966); Hunter College, New York
(1968–70)

Lives in New York and Carbondale, Colorado

Selected One-Artist Exhibitions

1972 98 Greene Street Loft, New York

1975 Holly Solomon Gallery, New York

1977 Holly Solomon Gallery, New York
(collaboration with Ned Smyth)

1979 Holly Solomon Gallery, New York

1980 Toni Birckhead Gallery, Cincinnati
The Mayor Gallery, London

1981 Holly Solomon Gallery, New York

1982 Holly Solomon Gallery, New York
(collaboration with Ned Smyth)

1983 Holly Solomon Gallery, New York

Selected Group Exhibitions

1966 University Gallery, University of Minnesota,
Minneapolis, "Some Young Minnesota
Artists"
Walker Art Center, Minneapolis, "Two
Person Show"

1972 Whitney Museum of American Art, New
York, "1972 Annual Exhibition: Con-
temporary American Painting"

1973 Whitney Museum of American Art, New
York, "American Drawings 1963–1973"

1975 The Clocktower, Institute for Art and Urban
Resources, New York, "Artists' Toys"
Art Museum of South Texas, Corpus Christi,
"Purchase Show"

1977 The American Foundation for the Arts,
Miami, "Patterning and Decoration"
(traveled to the Sewell Art Gallery, Rice
University, Houston)

P.S. 1, Institute for Art and Urban Re-
sources, Long Island City, New York,
"A Painting Show"
Sarah Lawrence College Gallery, Bronx-
ville, New York, "Painting 75 76 77"
(traveled to The American Foundation for
the Arts, Miami; Contemporary Arts
Center, Cincinnati)

1980 Mannheimer Kunstverein, Mannheim,
West Germany, "Dekor" (traveled to
Amerika House, West Berlin; Museum of
Modern Art, Oxford, England)
Neue Galerie/Sammlung Ludwig, Aachen,
West Germany, "Les Nouveaux Fauves—
Die Neuen Wilden"
United States Pavilion, 39th Venice Bien-
nale, Italy, "Drawings: The Pluralist
Decade" (traveled to the Institute of
Contemporary Art, University of Penn-
sylvania, Philadelphia)

1981 The New Museum, New York, "Alter-
natives in Retrospect: An Historical
Overview 1969–1975"
Sidney Janis Gallery, New York, "New
Directions: Contemporary American Art
from the Commodities Corporation Art
Collection" (traveled to the Museum of
Art, Fort Lauderdale, Florida; Oklahoma
Museum of Art, Oklahoma City; Santa
Barbara Museum of Art, California; Grand
Rapids Art Museum, Michigan; Madison
Art Center, Wisconsin; Montgomery
Museum of Fine Arts, Alabama)
Squibb Gallery, E. R. Squibb and Sons, Inc.,
Princeton, New Jersey, "Aspects of Post-
Modernism: Decorative and Narrative Art"

1982 Kestner-Gesellschaft, Hannover, West
Germany, "New York Now" (traveled to
Kunstverein, Munich; Musée Cantonal
des Beaux-Arts, Lausanne, Switzerland;
Kunstverein für die Rheinlande und West-
falen, Düsseldorf)

The Hudson River Museum, Yonkers, New York, "Ornamentalism: The New Decorativeness in Architecture and Design"

1983　The Berkshire Museum, Pittsfield, Massachusetts, "New Decorative Art"

Kunstmuseum, Lucerne, Switzerland, "Back to the U.S.A.: Amerikanische Kunst der Siebziger und Achtziger" (traveled to Rheinisches Landesmuseum, Bonn; Kunstverein, Stuttgart)

The Museum of Modern Art, New York, "Some Recent Acquisitions"

Selected Bibliography

Anderson, Alexandra. "Clay Gardens." *Portfolio*, 4 (March-April 1982), pp. 17–18.

Becker, Wolfgang. *Les Nouveaux Fauves—Die Neuen Wilden* (exhibition catalogue). Aachen, West Germany: Neue Galerie/Sammlung Ludwig, 1980.

Davis, Douglas. "Portrait of a Young Artist." *Time*, 99 (February 7, 1972), p. 79.

deAk, Edit. In "Reviews." *Artforum*, 16 (December 1977), p. 63.

French-Frazier, Nina. In "New York Exhibitions." *Art International*, 23 (December 1979), pp. 39–40.

Goldin, Amy. *Patterning and Decoration* (exhibition catalogue). Miami, Florida: The American Foundation for the Arts, 1977.

Grove, Nancy. "Brad Davis." *Arts Magazine*, 50 (December 1975), p. 13.

Haenlein, Carl. *New York Now* (exhibition catalogue). Hannover, West Germany: Kestner-Gesellschaft, 1982.

Honnef, Klaus. "New York Aktuelle." *Kunstforum International*, 61 (May 1983), pp. 37, 112–16.

Hunter, Sam. "Post-Modernist Painting." *Portfolio*, 4 (January-February 1982), pp. 46–53.

Jensen, Robert, and Patricia Conway. *Ornamentalism: The New Decorativeness in Architecture and Design*. New York: Clarkson N. Potter, 1982, pp. 20, 241, 251–53.

Kardon, Janet, ed. *Drawings: The Pluralist Decade* (exhibition catalogue). Philadelphia: Institute of Contemporary Art, University of Pennsylvania, 1980.

Larson, Kay. "Art." *The Village Voice*, September 24, 1979, p. 87.

Lawson, Thomas. "Brad Davis." *Flash Art*, no. 92–93 (October-November 1979), p. 23.

Lucie-Smith, Edward. *Art in the Seventies*. Ithaca, New York: Phaidon Books/Cornell University Press, 1980.

Morgan, Stuart. "Brad Davis at the Mayor Gallery, London." *Artscribe* (December 1980), pp. 42–43.

Oliva, Achille Bonito. "The Bewildered Image." *Flash Art*, no. 96–97 (March-April 1980), pp. 32–35.

———. "Transavantgarde." *Interarte 20*, May 1981, pp. 5–7, 16.

Rickey, Carrie. "Decoration, Ornament, Pattern and Utility: Four Tendencies in Search of a Movement." *Flash Art*, no. 90–91 (June-July 1979), pp. 19–23.

Tatransky, Valentin. "Brad Davis/Ned Smyth." *Arts Magazine*, 52 (November 1977), p. 28.

Tomkins, Calvin. "Matisse's Armchair." *The New Yorker*, 56 (February 25, 1980), pp. 108–13.

Yau, John. "Brad Davis and Ned Smyth at Holly Solomon." *Art in America*, 66 (January-February 1978), pp. 114–15.

Bill Jensen

Born in Minneapolis, 1945

Studied at the University of Minnesota,
Minneapolis (B.F.A., 1968; M.F.A., 1970)

Lives in New York

Selected One-Artist Exhibitions

1973 Fischbach Gallery, New York

1974 The Gallery of July and August, Woodstock,
New York

1975 Fischbach Gallery, New York

1980 Washburn Gallery, New York

1981 Washburn Gallery, New York

1982 Washburn Gallery, New York

Selected Group Exhibitions

1976 Lowe Art Gallery, Syracuse University,
New York, "Contemporary Painting"
P.S. 1, Institute for Art and Urban Re-
sources, Long Island City, New York,
"Rooms P. S. 1"

1978 The New Museum, New York, "Double
Take"

1979 The Grey Art Gallery and Study Center,
New York University, "American
Painting: The Eighties: A Critical
Interpretation"

1980 Neuberger Museum, State University of
New York, College at Purchase, "Seven
Artists"

1981 University Art Museum, University of
California, Santa Barbara, "Contemporary
Drawings: In Search of an Image"
Whitney Museum of American Art, New
York, "1981 Biennial Exhibition"

1983 Hayden Gallery, Massachusetts Institute of
Technology, Cambridge, "Affinities:
Myron Stout, Bill Jensen, Brice Marden,
Terry Winters"
Whitney Museum of American Art, New
York, "Minimalism to Expressionism:
Painting and Sculpture Since 1965 from
the Permanent Collection"

Selected Bibliography

Foster, Hal. "A Tournament of Rose's." *Artforum*,
18 (November 1979), pp. 62–67.

Halbreich, Kathy. *Affinities: Myron Stout, Bill
Jensen, Brice Marden, Terry Winters* (exhi-
bition catalogue). Cambridge: Hayden Gallery,
Massachusetts Institute of Technology, 1983.

Heiss, Alanna, ed. *Rooms P. S. 1* (exhibition cata-
logue). Long Island City, New York: Institute
for Art and Urban Resources, Inc., 1977.

Henry, Gerrit. In "Reviews and Previews." *Art
News*, 72 (May 1973), p. 86.

Kramer, Hilton. "Art: Bill Jensen Works Shown."
The New York Times, November 13, 1981,
p. C24.

1981 Biennial Exhibition (exhibition catalogue).
Foreword by Tom Armstrong. Preface by John G.
Hanhardt, Barbara Haskell, Richard Marshall,
and Patterson Sims. New York: Whitney
Museum of American Art, 1981.

Parks, Addison. "Bill Jensen and the Sound and
Light Beneath the Lid." *Arts Magazine*, 56
(November 1981), pp. 152–55.

Perreault, John. "Ryder on the Storm." *The SoHo
Weekly News*, November 11–17, 1981.

Plous, Phyllis. *Contemporary Drawings: In Search
of an Image* (exhibition catalogue). Santa
Barbara, California: University Art Museum,
University of California, 1981.

Rose, Barbara. *American Painting: The Eighties:
A Critical Interpretation* (exhibition catalogue).
New York: The Grey Art Gallery and Study
Center, New York University, 1979.

Smith, Roberta. In "Reviews." *Artforum*, 11
(June 1973), pp. 88–89.

———. "Bill Jensen's Abstractions." *Art in
America*, 68 (November 1980), pp. 109–13.

Elizabeth Murray

Born in Chicago, 1940

Studied at the School of The Art Institute of Chicago (B.F.A., 1962); Mills College, Oakland, California (M.F.A., 1964)

Lives in New York

Selected One-Artist Exhibitions

1975 Paula Cooper Gallery, New York
The Jared Sable Gallery, Toronto

1976 Paula Cooper Gallery, New York

1978 Paula Cooper Gallery, New York
Phyllis Kind Gallery, Chicago

1980 Galerie Mukai, Tokyo

1981 Paula Cooper Gallery, New York

1982 Daniel Weinberg Gallery, Los Angeles

1983 Paula Cooper Gallery, New York
Portland Center for the Visual Arts, Oregon

Selected Group Exhibitions

1972 Whitney Museum of American Art, New York, "1972 Annual Exhibition: Contemporary American Painting"

1973 Whitney Museum of American Art, New York, "1973 Biennial Exhibition: Contemporary American Art"

1977 The Solomon R. Guggenheim Museum, New York, "Nine Artists: The Theodoron Awards"
Museum of Contemporary Art, Chicago, "A View of a Decade"
The New Museum, New York, "Early Works by Five Contemporary Artists: Ron Gorchov, Elizabeth Murray, Dennis Oppenheim, Dorothea Rockburne, Joel Shapiro"
New York State Museum, Albany, "New York: The State of Art"

1979 The Grey Art Gallery and Study Center, New York University, "American Painting: The Eighties: A Critical Interpretation"
Hayward Gallery, London, "New Work/New York"

Whitney Museum of American Art, New York, "1979 Biennial Exhibition"

1981 Haus der Kunst, Munich, "Amerikanische Malerei: 1930–1980"
Whitney Museum of American Art, New York, "1981 Biennial Exhibition"

1982 The Art Institute of Chicago, "74th American Exhibition"
Whitney Museum of American Art, New York, "Abstract Drawings, 1911–1981"

1983 Hirshhorn Museum and Sculpture Garden, Smithsonian Institution, Washington, D.C., "Directions 1983"
The Museum of Modern Art, New York, "Some Recent Acquisitions"
Whitney Museum of American Art, New York, "Minimalism to Expressionism: Painting and Sculpture Since 1965 from the Permanent Collection"

Selected Bibliography

Armstrong, Tom. *Amerikanische Malerei: 1930–1980* (exhibition catalogue). Munich: Prestel-Verlag and Haus der Kunst, 1981.

Cohen, Ronny H. "Elizabeth Murray's Colored Space." *Artforum*, 21 (December 1982), pp. 51–55.

Fleming, Lee. "Biennial Directions—Directions 1983." *Art News*, 83 (Summer 1983), pp. 79–82.

Gilbert-Rolfe, Jeremy. In "Reviews." *Artforum*, 12 (January 1974), p. 70.

Kuspit, Donald B. "Elizabeth Murray's Dandyish Abstraction." *Artforum*, 16 (February 1978), pp. 28–31.

Moore, Alan. In "Reviews." *Artforum*, 13 (April 1975), pp. 82–83.

Morgan, Stuart. "New Work/New York at the Hayward Gallery." *Artscribe*, July 1979.

Murry, Jesse. "Quintet: The Romance of Order and Tension in Five Paintings by Elizabeth Murray." *Arts Magazine*, 55 (May 1981), pp. 102–5.

Nadelman, Cynthia. "Elizabeth Murray." *Art News*, 81 (September 1982), pp. 76–77.

Perrone, Jeff. In "Review." *Artforum*, 17 (January 1979), pp. 65–66.

————. "Notes on the Whitney Biennial." *Images and Issues*, 2 (Summer 1981), pp. 46–49.

Phillips, Deborah C. "Elizabeth Murray at Paula Cooper." *Images and Issues*, 2 (Fall 1981), p. 66.

Rose, Barbara. *American Painting: The Eighties: A Critical Interpretation* (exhibition catalogue). New York: The Grey Art Gallery and Study Center, New York University, 1979.

Russell, John. "Painting Is Once Again Provocative." *The New York Times*, April 17, 1983, p. C1.

Shearer, Linda. *Nine Artists: The Theodoron Awards* (exhibition catalogue). New York: The Solomon R. Guggenheim Museum, 1977.

Smith, Roberta. In "Reviews." *Artforum*, 13 (May 1975), p. 72.

————. "Elizabeth Murray at Paula Cooper." *Art in America*, 65 (March-April 1977), p. 114.

————. "Elizabeth Murray at Paula Cooper." *Art in America*, 67 (March-April 1979), pp. 150–51.

————. "Biennial Blues." *Art in America*, 69 (April 1981), pp. 92–101.

————. "Abstract Extractions." *The Village Voice*, June 8, 1982, p. 83.

————. "Art: Healthy Egos." *The Village Voice*, May 3, 1983.

Gary Stephan

Born in Brooklyn, New York, 1942

Studied at Parsons School of Design, New York
(1960–61); Art Students League, New York
(1961); Pratt Institute, New York (1961–64);
San Francisco Art Institute (M.F.A., 1967)

Lives in New York

Selected One-Artist Exhibitions

1970 David Whitney Gallery, New York

1971 Quay Gallery, San Francisco

1972 Hans Neuendorf Gallery, Cologne,
West Germany

1973 Galerie Ostergren, Malmö, Sweden
Texas Gallery, Houston
Daniel Weinberg Gallery, San Francisco

1974 Bykert Gallery, New York

1975 Bykert Gallery, New York

1976 Bykert Gallery, New York
Texas Gallery, Houston

1977 Daniel Weinberg Gallery, San Francisco

1978 Mary Boone Gallery, New York

1979 Mary Boone Gallery, New York
Margo Leavin Gallery, Los Angeles

1980 Mary Boone Gallery, New York

1981 Mary Boone Gallery, New York
Margo Leavin Gallery, Los Angeles
Mattingly-Baker Gallery, Dallas

1982 Mary Boone Gallery, New York
Greenberg Gallery, Saint Louis
Daniel Weinberg Gallery, San Francisco

1983 Margo Leavin Gallery, Los Angeles

Selected Group Exhibitions

1969 Whitney Museum of American Art,
New York, "1969 Annual Exhibition:
Contemporary American Painting"

1970 Contemporary Arts Center, Cincinnati,
"Young American Artists"

1972 Contemporary Arts Museum, Houston,
"John Baldessari, Frances Barth, Richard
Jackson, Barbara Munger, Gary Stephan"

Whitney Museum of American Art,
New York, "1972 Annual Exhibition:
Contemporary American Painting"

1973 Art Museum of South Texas, Corpus
Christi, "Eight Artists: Dan Christensen,
Neil Jenney, Don Judd, Roy Lichtenstein,
Robert Rauschenberg, Gary Stephan, Cy
Twombly, Peter Young"
Whitney Museum of American Art,
New York, "1973 Biennial Exhibition:
Contemporary American Art"
Pratt Institute, New York, "Recent
Abstract Painting"

1974 The Art Institute of Chicago, "71st
American Exhibition"

1976 Georgia State University Art Gallery,
Atlanta, "Ten Painters"

1977 Brooke Alexander Gallery, New York,
"Selected Prints"
Galerie Loyse von Oppenheim, Nyon,
Switzerland, "Eleven Artists in New York"
P.S. 1, Institute for Art and Urban
Resources, Long Island City, New
York, "A Painting Show"
Sarah Lawrence College Gallery, Bronx-
ville, New York, "Painting 75 76 77"
(traveled to The American Foundation for
the Arts, Miami; Contemporary Arts
Center, Cincinnati)

1979 The Grey Art Gallery and Study Center,
New York University, "American
Painting: The Eighties: A Critical
Interpretation"

1981 Ben Shahn Gallery, William Patterson
College, Wayne, New Jersey, "Drawings"

1982 The Aldrich Museum of Contemporary Art,
Ridgefield, Connecticut, "Post-
minimalism"
Hamilton Gallery, New York, "The
Abstract Image"
Hayden Gallery, Massachusetts
Institute of Technology, Cambridge,
"Great Big Drawings"

The New Museum, New York, "Early
Work: Lynda Benglis, Joan Brown, Luis
Jiminez, Gary Stephan, Lawrence Weiner"

1983 The Solomon R. Guggenheim Museum,
New York, "Recent Acquisitions: Works
on Paper"

Selected Bibliography

Baker, Kenneth. In "New York." *Artforum*, 10
(January 1972), pp. 86–87.

Foster, Hal. "A Tournament of Rose's." *Artforum*,
18 (November 1979), pp. 62–67.

Frank, Peter. In "Reviews and Previews." *Art
News*, 73 (March 1974), p. 103.

Galassi, Susan Grace. "Color and Surface: Review
of Touchstone Show." *Arts Magazine*, 54 (March
1980), p. 22.

Henry, Gerrit. In "New York Reviews." *Art News*,
75 (April 1976), p. 120.

Kertess, Klaus. "Figures of Paint: The Work of
Gary Stephan." *Arts Magazine*, 52 (March 1978),
pp. 138–39.

———. "Figuring It Out." *Artforum*, 19
(November 1980), pp. 30–35.

———. "Painting Metaphorically: The Recent
Work of Gary Stephan, Stephen Mueller, Bill
Jensen." *Artforum*, 20 (October 1981), pp. 54–58.

Lawson, Thomas. "Gary Stephan." *Flash Art*,
no. 103 (Summer 1981), p. 53.

Leonard, William A., and Michael Findlay. *Young
American Artists* (exhibition catalogue).
Cincinnati: Contemporary Arts Center, 1970.

Liebmann, Lisa. "Gary Stephan." *Artforum*, 21
(October 1982), p. 71.

Masheck, Joseph. "Iconicity." *Artforum*, 17
(January 1979), pp. 30–41.

Mayer, Rosemary. In "Reviews: New York." *Arts
Magazine*, 47 (March 1973), p. 72.

Neher, Ross. "Mentalism versus Painting."
Artforum, 17 (February 1979), pp. 40–47.

Nelson, Katherine Metcalf. "San Francisco." *Art
News*, 65 (October 1966), pp. 59–62.

Perrone, Jeff. "Gary Stephan." *Artforum*, 16
(Summer 1978), pp. 70–71.

Pincus-Witten, Robert. "Entries." *Arts Magazine*,
50 (March 1976), pp. 9–11.

———. "Entries." *Arts Magazine*, 52 (March
1978), pp. 92–93.

———. "Entries: Cutting Edges." *Arts Magazine*,
53 (June 1979), pp. 108–9.

———. "Entries: Big History, Little History."
Arts Magazine, 54 (April 1980), p. 185.

———. "Entries: If Even in Fractions." *Arts
Magazine*, 55 (September 1980), p. 119.

———. "Gary Stephan: The Brief Against
Matisse." *Arts Magazine*, 56 (March 1982),
pp. 132–37.

———. "Entries: Increments of Inaccessibility."
Arts Magazine, 57 (April 1983), pp. 108–10.

Ratcliff, Carter. "New York Letter." *Art
International*, 16 (January 1972), pp. 68–69.

Reed, Dupuy Warrick. "Gary Stephan: Beyond
Language." *Arts Magazine*, 54 (May 1980),
pp. 159–63.

Renna, Nina. "1981 Painting Invitational." *Arts
Magazine*, 55 (March 1981), p. 23.

Ricard, Rene. "Not About Julian Schnabel."
Artforum, 19 (Summer 1981), pp. 74–80.

Rose, Barbara. *American Painting: The Eighties:
A Critical Interpretation* (exhibition catalogue).
New York: The Grey Art Gallery and Study
Center, New York University, 1979.

Smith, Roberta Pancoast. In "Whitney Biennial:
Four Views." *Arts Magazine*, 47 (March 1973),
p. 65.

———. "Review." *Artforum*, 12 (April 1974),
p. 76.

———. "Review." *Artforum*, 14 (May 1976),
pp. 64–65.

Storr, Robert. "Gary Stephan at Mary Boone."
Art in America, 71 (May 1983), p. 163.

Tarshis, Jerome. In "San Francisco." *Artforum*,
9 (June 1971), p. 92.

Tatransky, Valentin. "Arts Reviews: Group Show." *Arts Magazine*, 52 (March 1978), p. 16.

———. "Gary Stephan." *Arts Magazine*, 52 (June 1978), p. 11.

———. "Drawing Show." *Arts Magazine*, 53 (March 1979), p. 33.

———. "Gary Stephan." *Arts Magazine*, 53 (June 1979), p. 36.

Whitney, David. *Eight Artists: Dan Christensen, Neil Jenney, Don Judd, Roy Lichtenstein, Robert Rauschenberg, Gary Stephan, Cy Twombly, Peter Young* (exhibition catalogue). Corpus Christi: Art Museum of South Texas, 1973.

Yoskowitz, Robert. "Group Show." *Arts Magazine*, 54 (December 1979), pp. 21–22.

———. "Gary Stephan." *Arts Magazine*, 57 (September 1982), pp. 33–34.

John Torreano

Born in Flint, Michigan, 1941
Studied at Cranbrook Academy of Art, Bloomfield,
 Michigan (B.F.A., 1961); Ohio State University,
 Columbus (M.A., 1967)
Lives in New York

Selected One-Artist Exhibitions

1971 Reese Paley Gallery, San Francisco

1974 Artists Space, New York

1975 Susan Caldwell Gallery, New York

1976 Bykert Gallery, New York

1977 Droll/Kolbert Gallery, New York
 Nancy Lurie Gallery, Chicago

1979 Droll/Kolbert Gallery, New York
 Nancy Lurie Gallery, Chicago

1980 Joslyn Art Museum, Omaha

1981 Hamilton Gallery, New York
 Young/Hoffman Gallery, Chicago

1982 Susanne Hilberry Gallery, Birmingham,
 Michigan

1983 Hamilton Gallery, New York

Selected Group Exhibitions

1969 Whitney Museum of American Art,
 New York, "1969 Annual Exhibition:
 Contemporary American Painting"

1971 Whitney Museum of American Art, New
 York, "Lyrical Abstraction"

1972 Madison Art Center, Wisconsin, "New
 American Abstract Painting"

1974 Paula Cooper Gallery, New York, "Three
 Artists"

1976 Alessandra Gallery, New York, "Ten
 Approaches to the Decorative"

1977 P.S. 1, Institute for Art and Urban
 Resources, Long Island City, New
 York, "A Painting Show"

1978 Fine Arts Galleries, University of South
 Florida, Tampa, "Two Decades of
 Abstraction"

The Queens Museum, Flushing, New
 York, "Private Myths: Unearthings of
 Contemporary Art"
Renaissance Society at the University of
 Chicago, "Thick Paint"
Whitney Museum of American Art, New
 York, "American Art 1950 to the Present"

1979 Neuberger Museum, State University of
 New York, College at Purchase, "10
 Artists/Artists Space"
 Palazzo Reale, Milan, "Pittura Ambiente"

1980 Museum of Contemporary Art, Chicago,
 "3 Dimensional Painting"
 Galerie Gillespie-Laage-Salomon, Paris,
 "Trois Dimensions—Sept Américains"
 P.S. 1, Institute for Art and Urban
 Resources, Long Island City, New York,
 "Watercolor Exhibition"
 Whitney Museum of American Art, New
 York, Downtown Branch, "Painting in
 Relief"

1981 Oscarsson Hood Gallery, New York, "The
 New Spiritualism"

1982 Contemporary Arts Museum, Houston,
 "The Americans: Collage"
 Wave Hill, Bronx, New York, "New
 Perspectives"

Selected Bibliography

Baur, John I. H., and Larry Aldrich. *Lyrical
 Abstraction* (exhibition catalogue). New York:
 Whitney Museum of American Art, 1971.

Casademont, Joan. "John Torreano, Hamilton
 Gallery." *Artforum*, 20 (January 1982), p. 38.

Cavaliere, Barbara. "John Torreano." *Arts
 Magazine*, 52 (January 1978), p. 31.

Day, Holliday T. *I-80 Series: John Torreano*
 (exhibition catalogue). Omaha: Joslyn Art
 Museum, 1980.

Delehanty, Suzanne. *10 Artists/Artists Space*
 (exhibition catalogue). Purchase, New York:
 Neuberger Museum, State University of New
 York, College at Purchase, 1979.

Foster, Hal. "John Torreano, Droll/Kolbert Gallery." *Artforum*, 18 (February 1980), pp. 98–99.

Gilbert-Rolfe, Jeremy. In "Reviews." *Artforum*, 12 (June 1974), p. 69.

Henry, Gerrit. "John Torreano (Hamilton)." *Art News*, 81 (February 1982), p. 161.

Kuspit, Donald B. "Cosmetic Transcendentalism: Surface-Light in John Torreano, Rodney Ripps and Lynda Benglis." *Artforum*, 18 (October 1979), pp. 38–40.

———. "John Torreano at Hamilton." *Art in America*, 70 (January 1982), pp. 138–39.

Lawson, Thomas. "Painting in New York: An Illustrated Guide." *Flash Art*, no. 92–93 (October-November 1979), pp. 4–11.

Owens, Craig. *New Perspectives* (exhibition catalogue). Bronx, New York: Wave Hill, 1982.

Perrone, Jeff. "Approaching the Decorative." *Artforum*, 15 (December 1976), p. 30.

Ratcliff, Carter. "Painterly Versus Painted." *Art News Annual*, 1976.

———. "The Paint Thickens." *Artforum*, 14 (Summer 1976), pp. 43–47.

Rickey, Carrie. "John Torreano, Droll/Kolbert." *Flash Art*, no. 94–95 (January-February 1980), p. 27.

Tannenbaum, Judith. *3 Dimensional Painting* (exhibition catalogue). Chicago: Museum of Contemporary Art, 1980.

Torreano, John. "Painters Reply . . ." *Artforum*, 14 (September 1975), p. 36.

Zimmer, William. "Smalltown Weather Scapes." *The SoHo Weekly News*, November 3, 1977, p. 38.

———. "All That Glitters." *The SoHo Weekly News*, November 29, 1979, p. 26.

Works in the Exhibition

Dimensions are in inches, followed by centimeters; height precedes width.

Brad Davis

Guerrilla Warfare, 1971–73
Acrylic and metal leaf on canvas, 100¾ x
 81 (255.9 x 205.7)
Whitney Museum of American Art, New
 York; Gift of Mr. and Mrs. William A.
 Marsteller (and purchase) 73.72

Eagle, 1972
Acrylic and oil pastel on canvas, 91½ x
 182 (232.4 x 462.3)
Collection of Holly and Horace Solomon

Black Orchid, 1975
Acrylic and oil pastel on canvas, 96 x 44
 (243.8 x 111.8)
Collection of Mr. and Mrs. Morton
 Hornick

Blue Zig Zag, 1975
Acrylic, oil pastel, and graphite on canvas,
 96 x 44 (243.8 x 111.8)
Collection of Joseph Spellman

In the Daffodils, 1980
Acrylic and polyester fabric on canvas,
 48 (121.9) diameter
Private collection

Ming Snapshots #1–#5, 1980
Acrylic and polyester fabric on canvas,
 five panels, each 42 x 42 (106.7 x
 106.7)
Collection of the Right Honourable the
 Earl of Ronaldshay

Summer Wind, 1980
Acrylic and polyester fabric on canvas,
 72 (182.9) diameter
Private collection

Top of the Peak, 1980
Acrylic and polyester fabric on canvas,
 48 (121.9) diameter
Collection of the artist, courtesy Holly
 Solomon Gallery, New York

Dürer's Dogs, 1981
Acrylic and polyester fabric on canvas,
 three panels, 60½ x 140 (153.7 x 355.6)
 overall
The Gelco Collection, Gelco Corporation,
 Eden Prairie, Minnesota

Evening Shore, 1983
Acrylic and polyester fabric on canvas,
 72 x 98 (182.9 x 248.9)
Private collection

Jamaican Inlet, 1983
Acrylic and polyester fabric on canvas,
 42 x 180 (106.7 x 457.2)
Collection of Martin Sklar

Bill Jensen

Last, 1973
Oil and pigment on canvas, 96½ x 77
 (245.1 x 195.6)
Collection of the artist, courtesy
 Washburn Gallery, New York

Dark Silver, 1974
Oil on linen on wood, 22 x 28 (55.9 x
 71.1)
Collection of Edith Gould

Black and White Painting, 1974–75
Oil, enamel, and enamelac on paper on
 wood, 11 x 9 (27.9 x 22.9)
Collection of the artist, courtesy
 Washburn Gallery, New York

The Purple Painting, 1975
Oil on linen, 18 x 16 (45.7 x 40.6)
Collection of Connie Reyes and
 Ronald Bladen

Freak, 1975–76
Oil on linen, 16 x 20 (40.6 x 50.8)
Collection of the artist, courtesy
 Washburn Gallery, New York

The Red Painting, 1975–76
Oil on linen, 18 x 22 (45.7 x 55.9)
Collection of the artist, courtesy
 Washburn Gallery, New York

The Snail, 1975–76
Oil on linen, 17⅞ x 19¾ (45.4 x 50.2)
Collection of Margarit Lewczuk

Innocence, 1976
Oil on linen, 12½ x 18 (31.8 x 45.7)
Collection of Mrs. William D. Carlebach

Redon, 1977
Oil on linen, 20 x 16 (50.8 x 40.6)
Collection of Edward R. Downe, Jr.

Mussels, 1977–78
Oil on linen, 20 x 16 (50.8 x 40.6)
Collection of Sue and David Workman

Resurrection, 1978
Oil on linen, 22 x 22 (55.9 x 55.9)
Collection of Phil Schrager

Crown of Thorns, 1979
Oil on linen, 16 x 11 (40.6 x 27.9)
Collection of Jerry Leiber

Mute, 1979
Oil on linen, 36 x 24 (91.4 x 61)
Collection of Henry and Maria Feiwel

Seed of the Madonna, 1979
Oil on canvas, 20 x 16 (50.8 x 40.6)
Collection of Reeds Hill Foundation,
 Carlisle, Massachusetts

The Family, 1980–81
Oil on linen, 20 x 36 (50.8 x 91.4)
Collection of Henry and Maria Feiwel

Shaman, 1980–81
Oil on linen, 20 x 15 (50.8 x 38.1)
Collection of Mr. and Mrs. Edward R.
 Hudson, Jr.

Memory of Closeness, 1981
Oil on linen, 26¼ x 20 (66.7 x 50.8)
The Metropolitan Museum of Art, New
 York; Purchase, Louis and Bessie Adler
 Foundation Inc., Gift (Seymour M.
 Klein, President)

Elizabeth Murray

Pink Spiral Leap, 1975
Oil on canvas, 78 x 76 (198.1 x 193)
Collection of Lewis and Susan Manilow

Beginner, 1976
Oil on canvas, 113 x 114 (287 x 289.6)
Collection of Doris and Charles Saatchi

Traveler's Dream, 1978
Oil on canvas, 102½ x 87 (260.3 x 221)
University Gallery of Fine Art, Ohio
 State University, Columbus; Purchased
 with funds from the National Endow-
 ment for the Arts and the Ohio State
 University Development Fund

Art Part, 1981
Oil on canvas, 115 x 124 (292.1 x 315)
Private collection

Fly By, 1982
Oil on canvas, 106 x 76 (269.2 x 193)
Collection of Mr. and Mrs. Marvin
 Gerstin

Sentimental Education, 1982
Oil on canvas, 124½ x 86 (316.2 x 218.4)
Collection of Michael and Judy Ovitz

Yikes, 1982
Oil on canvas, 116 x 113 (294.6 x 287)
Collection of Douglas S. Cramer

Deeper than D, 1983
Oil on canvas, 106 x 102 (269.2 x 259.1)
Private collection

Gary Stephan

Chinatown, 1973–74
Oil and acrylic on jute, 89 x 108 (226.1 x
 274.3)
Collection of the artist,
Courtesy Mary Boone Gallery, New York

Untitled (from the Garden Cycle), 1975
Acrylic on canvas, 44 x 44 (111.8 x 111.8)
Collection of the artist,
Courtesy Mary Boone Gallery, New York

Natural Language—September, 1978
Acrylic on canvas, 72 x 54 (182.9 x 137.2)
Collection of William J. Hokin

Master—Quicksilver, 1980
Acrylic on canvas, 88 x 53 (223.5 x 134.6)
Collection of Helen N. Lewis and Marvin
 B. Meyer

Bells and Thought, 1981
Acrylic on canvas, 108 x 72 (274.3 x
 182.9)
Collection of Dupuy Warrick Reed

Oh Ye of Mental Men, 1981
Acrylic on canvas, 96 x 96 (243.8 x 243.8)
Collection of Barbara and Eugene
 Schwartz

The Brazen Serpent of Moses, 1982
Acrylic on linen and muslin, wood, 96 x
 71 (243.8 x 180.3)
Collection of Adrian and Robert E.
 Mnuchin

Lights, 1982
Acrylic on canvas, 90 x 72¼ (228.6 x
 183.5)
Collection of Pamela and Arthur Sanders

Sator
Arepo
Tenet
Opera
Rotas, 1982
Oil on canvas and linen, 89 x 84 (226.1 x
 213.4)
The Metropolitan Museum of Art, New
 York; Purchase, George A. Hearn
 Fund, and Eugene M. Schwartz, Gift

Mental Value, 1983
Acrylic on canvas and wood, 90 x 84
 (228.6 x 213.4)
Mary Boone Gallery, New York, and
Margo Leavin Gallery, Los Angeles

The Rules of Appearance, 1983
Acrylic on linen, wood, and styrofoam,
 86 x 31½ (218.4 x 80)
Mary Boone Gallery, New York, and
Margo Leavin Gallery, Los Angeles

John Torreano

Big Red, 1974
Oil and glass jewels on canvas, 60 x 60
　(152.4 x 152.4)
Collection of Susan and Bill Pigman

Column, 1975
Oil and glass jewels on wood, 96 x 8
　(243.8 x 20.3)
Collection of Mr. and Mrs. Boyd Mefferd

Column, 1975
Oil and glass jewels on wood, 96 x 8
　(243.8 x 20.3)
Collection of Doris and Charles Saatchi

Universe Paintings, 1975
Oil, acrylic, and glass jewels on wood and
　polyester spheres, dimensions vary from
　6 to 15 (15.2 to 38.1) diameter
Collection of the artist

Split, 1976
Oil and glass jewels on canvas, 48 x 168
　(121.9 x 426.7)
Collection of Fred Mueller

Grapes, 1979
Acrylic and glass jewels on canvas, 72 x
　72 (182.9 x 182.9)
Collection of Phil Schrager

Medal, 1979
Acrylic and glass jewels on canvas, 72 x
　72 (182.9 x 182.9)
Collection of the artist

Crab Nebula, 1980
Oil and glass jewels on canvas, 84 x 84
　(213.4 x 213.4)
Collection of Camille and Paul
　Oliver Hoffmann, courtesy Rhona
　Hoffman Gallery, Chicago

Irish Cousin II, 1980
Acrylic and glass jewels on canvas, 72 x
　72 (182.9 x 182.9)
Collection of Gloria and David Leader

Irish Cross, 1981
Acrylic, silicon glue, and glass jewels on
　wood, 31½ x 31½ (80 x 80)
Collection of Martin Sklar

Orion, 1981
Acrylic and glass jewels on canvas, 102 x
　84 (259.1 x 213.4)
Private collection

Crystal Cross, 1982
Glass jewels on wood, 84 x 84 x 8 (259.1 x
　259.1 x 20.3)
Collection of the artist, courtesy Susanne
　Hilberry Gallery, Birmingham,
　Michigan

Amethyst Group, 1983
Acrylic on canvas, 84¼ x 66½ (214 x
　168.9)
Collection of the artist

Dates of the exhibition: March 21–June 17, 1984.
This publication was organized at the Whitney
Museum of American Art by Doris Palca, Head,
Publications and Sales; Sheila Schwartz, Editor;
Elaine Koss, Associate Editor; and Amy Curtis,
Secretary/Assistant.

Designer: Elizabeth Finger
Typesetter: Michael and Winifred Bixler
Printer: Eastern Press, Inc.